MANGA
FOR THE BEGINNER
kawaii

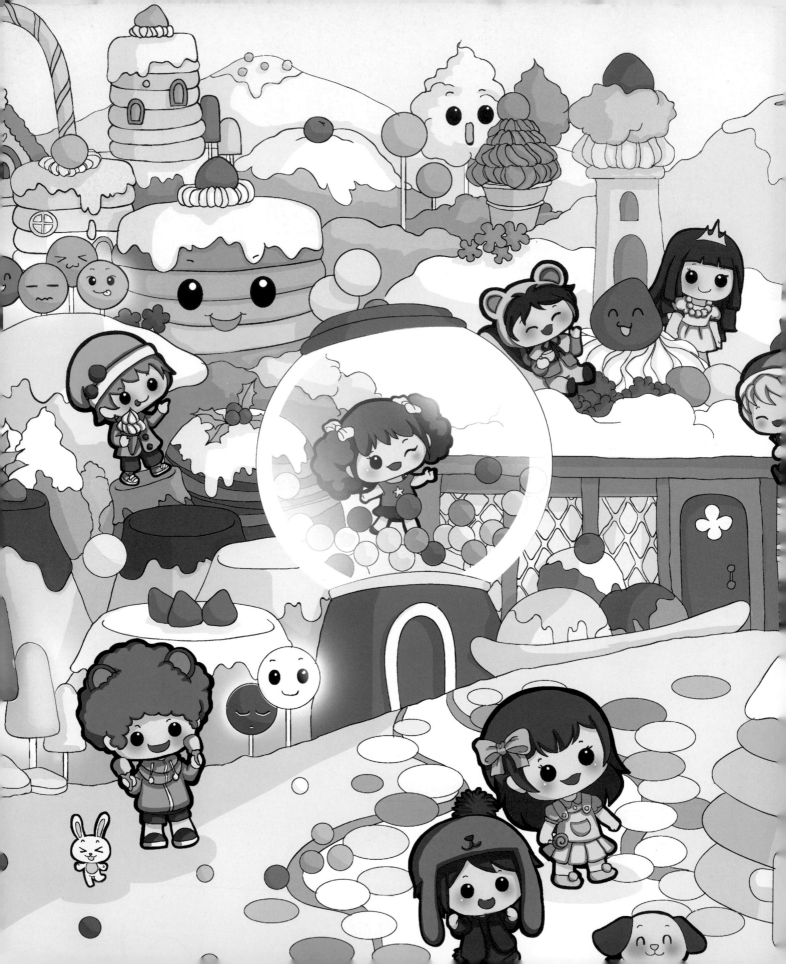

MANGA
FOR THE BEGINNER
kawaii

How to Draw the Supercute Characters of Japanese Comics

CHRISTOPHER HART

WATSON-GUPTILL PUBLICATIONS / NEW YORK

Copyright © 2012 by Cartoon Craft LLC

All rights reserved.
Published in the United States by Watson-Guptill Publications, an imprint of the Crown Publishing Group, a division of Random House, Inc., New York.
www.crownpublishing.com
www.watsonguptill.com

WATSON-GUPTILL is a registered trademark, and the WG and Horse designs are trademarks of Random House, Inc.

Library of Congress Cataloging-in-Publication Data
Hart, Christopher, 1957-

 Manga for the beginner kawaii : everything you need to draw the supercute characters of Japanese comics / Christopher Hart. — 1st ed.
 p. cm.
1. Comic books, strips, etc.—Japan—Technique. 2. Comic strip characters—Japan. 3. Figure drawing—Technique.
I. Title. II. Title: Everything you need to draw the supercute characters of Japanese comics.
 NC1764.5.J3H3692875 2012
 741.5'1—dc23
2011038160

ISBN 978-0-8230-0662-5
eISBN 978-0-8230-0663-2

Designed by La Tricia Watford
Cover design by Jess Morphew
Cover art by Novi Huans, Michele Liza Pelayre, Tesha Beaudry Okolowsky

Printed in China

10 9

First Edition

Contributing Artists

Akemi Kobayashi
Novi Huang
Rayteda Adetyar
PH
Tabby Kink
Morgan Long
Michele Liza Pelayre
Tesha Beaudry
Carol and Coutrney Regli and Bored, Inc.
Aurora Tejado
Additional material by Christopher Hart

The four basic necessities are shelter, food, water, and manga. How can anyone not get that?

—Christopher Hart,
pondering the meaning of life,
high atop Mount Everest

contents

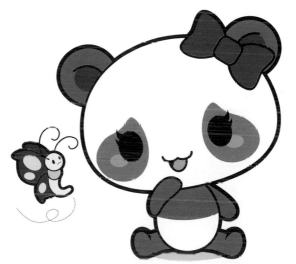

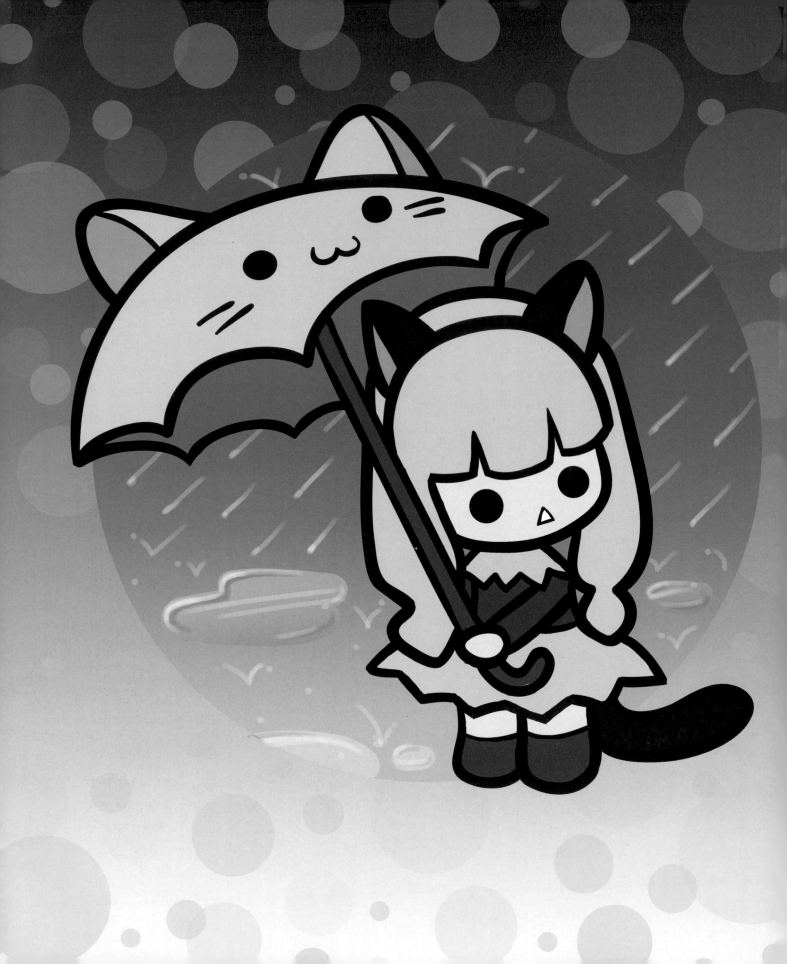

introduction

The term *kawaii* means "cute"

in Japanese. But to manga fans, it means much more than that. It's a pop-art style that's so hypercharming, so excruciatingly adorable that it has swept Japan, Europe, and is now exploding all across the United States. And look! It has landed in your hands, right here, in this profusely illustrated book that teaches the secrets to drawing this massively appealing art form.

Kawaii became an instant hit in the United States with the megafranchise *Hello Kitty*. Other supercute characters soon grew in popularity, including San-X, Pucca, and Domo. Kawaii characters show up everywhere, from manga to anime, and on all kinds of licensed products, such as clothing, bags, watches, and even wallpaper. You name it, Kawaii is on it.

In this book, you'll find a wide variety of character tutorials and clear, step-by-step illustrations. The book begins with an overview of the Kawaii style and its essential techniques, followed by chapters on Kawaii-based cat girls and anthros, evil cuties, adorable animals, fantasy creatures, cheerful foodies, and more. You'll learn the specific techniques that will enable you to take an ordinary character and, with a few short strokes of the pencil, totally transform it into a supercute character.

In addition, the book covers a very popular subgenre of Kawaii. Some would even call it a genre in itself, because it's virtually everywhere in Japan. That style is called moe (pronounced MOE-aye). In Japan, *Kawaii* not only refers to supercute characters but also to a genre of beautiful, elegantly drawn older teen girls. Moe characters are drawn at a superheightened level of femininity. They will dazzle you with their delicate prettiness and grace. They also feature perhaps the most amazing, and largest, eyes in all of manga—and that's saying something!

Finally, there is a section on creating Kawaii-style scenes and backgrounds, as well as how to draw your own irresistibly cute Kawaii greeting cards. Many professional manga artists got their start by drawing Kawaii characters for private commissions. This book features a valuable and exclusive interview with a two-artist team who started selling their Kawaii artwork modestly. Then step by step, they built their passion into a full-time business, which now licenses its many creations to major, name-brand retailers. They'll show you how they did it and how you can, too! You won't want to miss this.

If you're a manga artist, or want to be, then the Kawaii style is a great place to get started. It's easy to draw and vastly appealing. Getting good at drawing has never been this much fun.

how regular chibis compare to kawaii style

Most manga fans are familiar with chibis—the popular minipeople of Japanese graphic novels. You may think that Kawaii characters are the same as chibis. That's a common misconception. Kawaii-style chibis have a distinct, younger, and more stylized look—a look all their own.

regular chibis

* Head is more complex than a single shape, like a circle.
* Eyes feature "shines" as an important part of their characteristics.
* Individual strands of hair are articulated.
* Thin ink line is used.
* Costume contains details, such as folds and lapels.
* Hands are drawn with individual fingers.
* Colors are generally realistic.

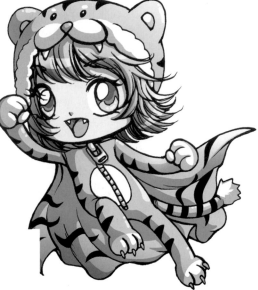

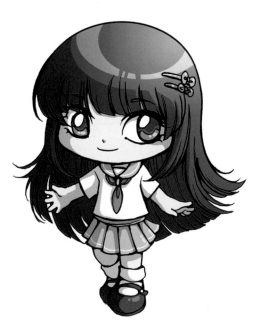

kawaii style

* Head is usually based on a simple shape (a circle or an oval).
* Eyes are most often black dots without shines.
* Hair is simplified.
* Outline is usually thick.
* Costume is bold but streamlined.
* Hands are simplified to eliminate fingers, although sometimes thumbs are still shown.
* Colors are bolder, splashier, and unrealistic.

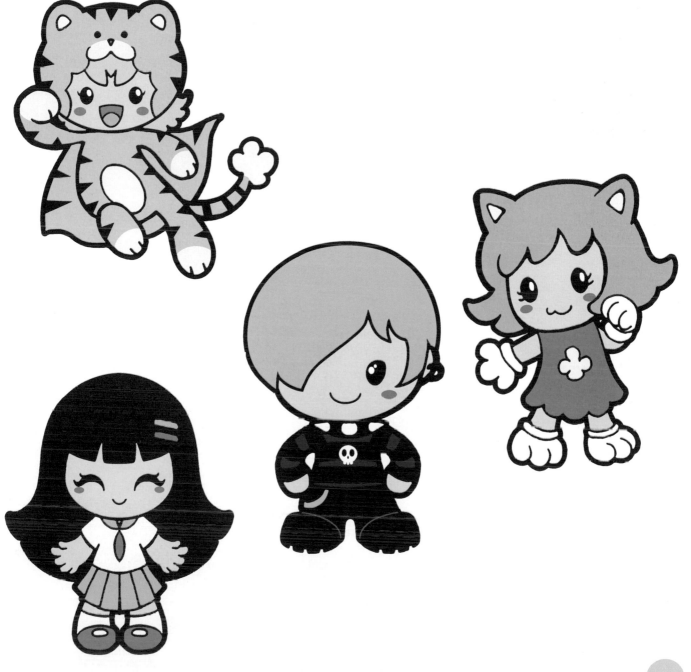

cute proportions

Drawing supercute means more than simply drawing supersmall. The proportions have to be cute, too. Now, you might be thinking, "Cute proportions? No one can create proportions that convey cuteness! It simply can't be done. Foolish mortal."

You can draw a wonderful character, with cute features and an adorable costume—but if the proportions are off from Kawaii standards, then there is no way it will ever be supercute.

classic kawaii proportions

To be supercute, the head must be bigger. It must be drawn much bigger than it would be on normal characters. How much bigger? Way, way, way, way bigger—until the head is bigger than the entire body.

1 1/2 HEADS TALL
This is the "it can't miss" gold standard of cute proportions. How cute is that?

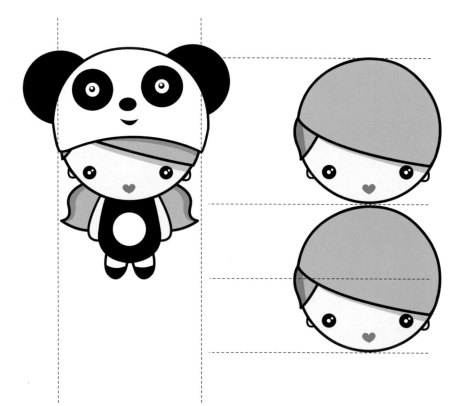

2 HEADS TALL

Hmmm. The character is getting a little on the tall side. Although this is pushing it a bit, it still makes it under the limbo stick.

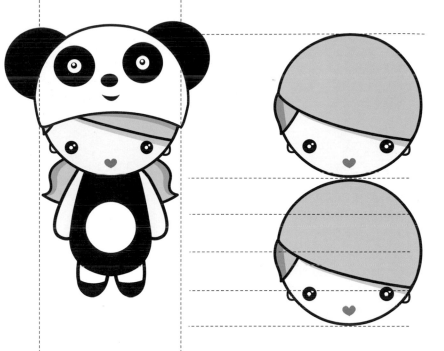

3 HEADS TALL

Whoa! This doesn't work. The added height gives the character a huge "cuteness deficit."

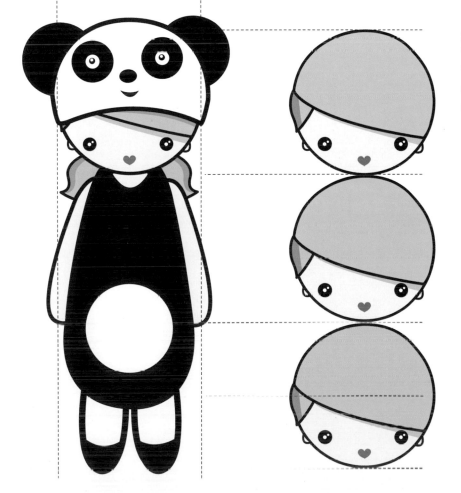

drawing the head

In manga, as in comic art, cartoons, and even realistic figure drawing, artists typically make small adjustments to the outline of the head, refining it as they create the character. But not so in Kawaii. The shapes that serve as the foundation of the head remain unchanged from beginning to end. This has a profound effect on the drawing. It creates the look of a graphic—a flat image, based on shapes executed in ultrastylized simplicity. At first glance, Kawaii appears so easy to draw. And, yes, it can be. But you have to understand the concepts that go into it. Many professional manga artists draw fantastic shoujo but have difficulty with the Kawaii style because they don't know how to add the right style to the basic foundation shapes.

Let's start with a typical, popular, Kawaii girl character as our example. She's cute, bubbly, with dot-style eyes, no nose, and a small smile. She wears her hair short and has a thing covering her head. Wait a minute—what the heck is that, anyway? That, my friends, is an anthro-hat (*anthro* refers to animals). It's an adorably drawn, animal-shaped hat (often a hood). Why is she wearing it? Because it exponentially increases the charm factor by 3.2501 percent.

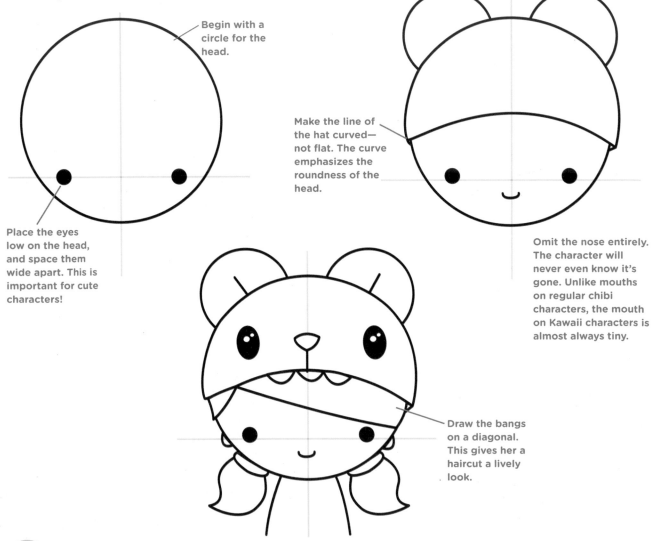

Begin with a circle for the head.

Place the eyes low on the head, and space them wide apart. This is important for cute characters!

Make the line of the hat curved—not flat. The curve emphasizes the roundness of the head.

Omit the nose entirely. The character will never even know it's gone. Unlike mouths on regular chibi characters, the mouth on Kawaii characters is almost always tiny.

Draw the bangs on a diagonal. This gives her a haircut a lively look.

Notice the thick linework in this step. Although not every Kawaii character is drawn with extrathick lines, many are. A thicker line makes the character look flatter, which, in turn, makes it look more stylish. It also pushes the needle a few notches higher on the Cute-O-Meter. This approach further carves out the unique identity of Kawaii.

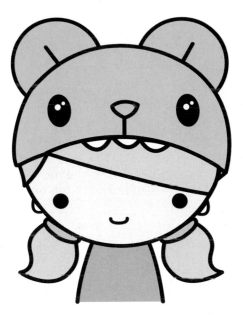

Apply the initial colors. Color themes vary according to the genre. This happy girl gets cheery colors, whereas a gothic girl would get a whole different color treatment.

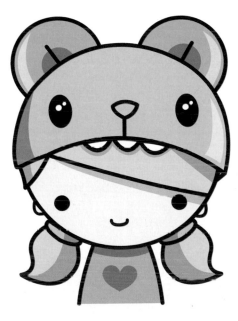

Adding highlights and shadows to the colors is optional but effective. For information on how to create highlights and shadows, see page 27.

QUICK TIP

You don't need to draw a perfect circle. Lots of artists draw them freehand. But if you want to try drawing characters with perfect circles, then I suggest purchasing something called a *template* at any art store or from an online art store. They're really inexpensive, because each one is just a piece of plastic. Templates come in all different sizes of circles that you can trace.

eye types

The most common eye type for Kawaii characters—humans, animals, or fantasy creatures—are dots; that is, black circles. However, they're not the only type used. Some artists use variations to create unique characters. But don't stray too far from the classic type. Drawing a small pupil surrounded by the white of the eye, for example, would not give your character a Kawaii look. Only draw the black pupil.

OVALS

FANCIFUL

INTERIOR SYMBOL (HEARTS)

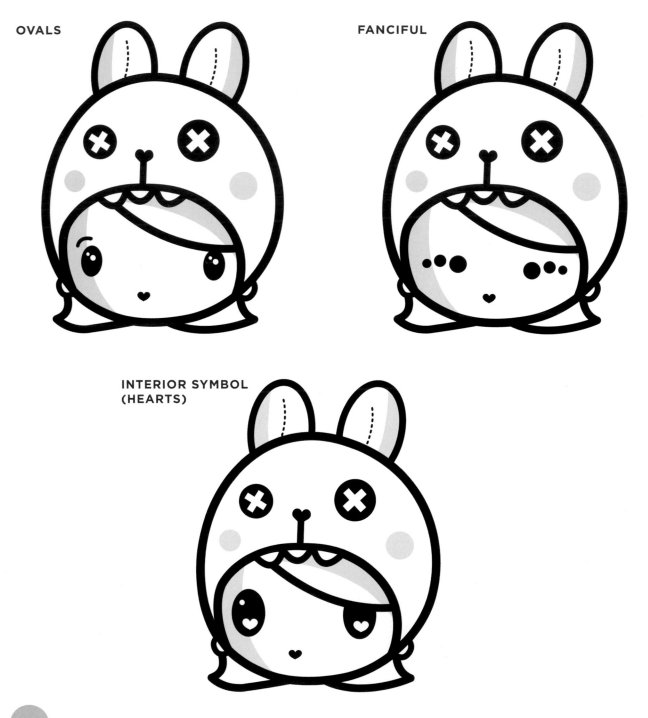

SMALL ALMOND

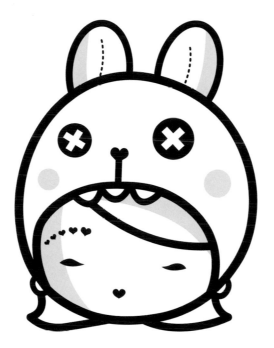

LARGE ALMOND

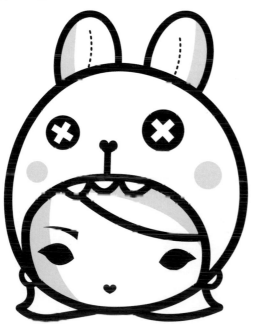

SIMPLE CURVED LINE

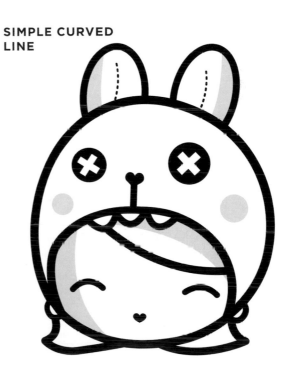

silly expressions

Kawaii is about communicating joy, fun, and good feelings. Appealing character design is essential. But character design itself isn't enough. If your character's expression is understated or, equally problematic, if it's too broad, you'll find yourself out of Charmingland without a map.

Although Kawaii expressions may be somewhat subdued, they're not subtle. It's always crystal clear what the character is feeling. Try to do more with less. The fewer lines you use to create an expression, the cuter it will look. That's the key to this style.

HAPPY

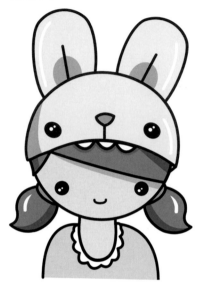

PLAYFUL

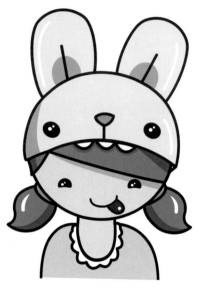

SAD

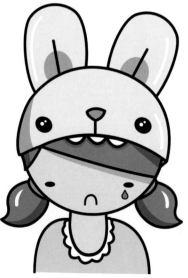

AMUSED

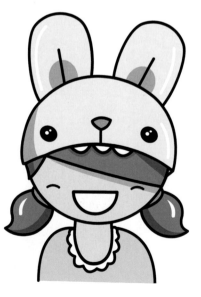

SLEEPY

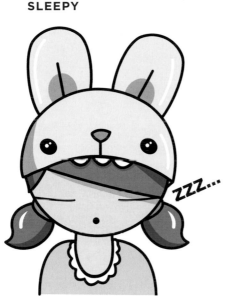

ANGRY

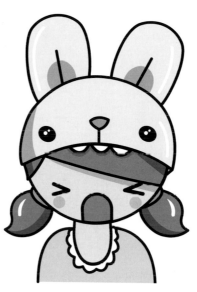

SURPRISED

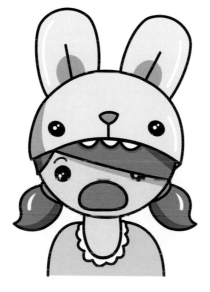

DISPLEASED

the full figure

The head is the focal point of every Kawaii character design. It's what creates the basic cute appeal. To that end, keep the size of the body small in comparison, so as not to divert attention from the adorableness.

This approach requires us to pack a lot of visual information into a small package—the body. Keep in mind two important things: First, it's cuter if your character appears to be slightly on the pudgy side. And second, since the body is so truncated, don't try to do too much with the pose. Dynamic or action poses subtract from the overall cuteness.

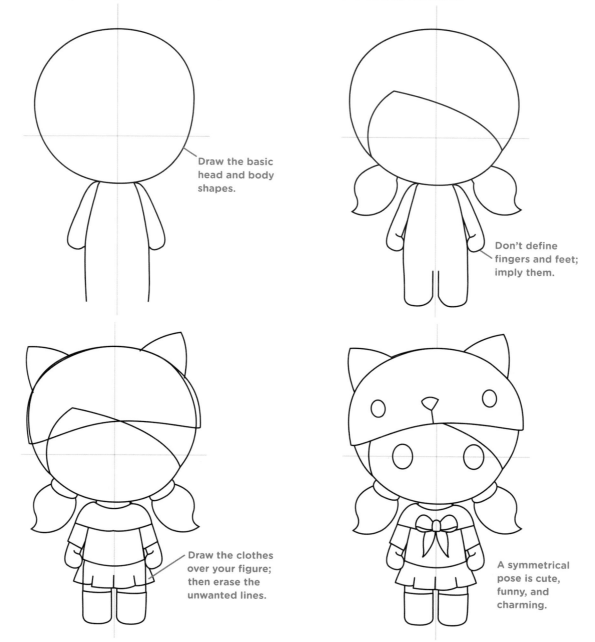

Draw the basic head and body shapes.

Don't define fingers and feet; imply them.

Draw the clothes over your figure; then erase the unwanted lines.

A symmetrical pose is cute, funny, and charming.

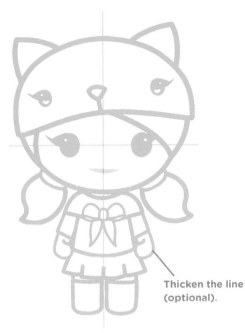

Thicken the line (optional).

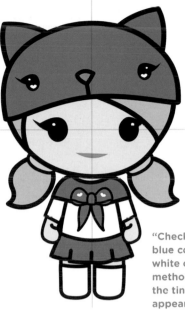

"Checkerboard" the blue colors with the white colors. This method prevents even the tiniest outfit from appearing cluttered.

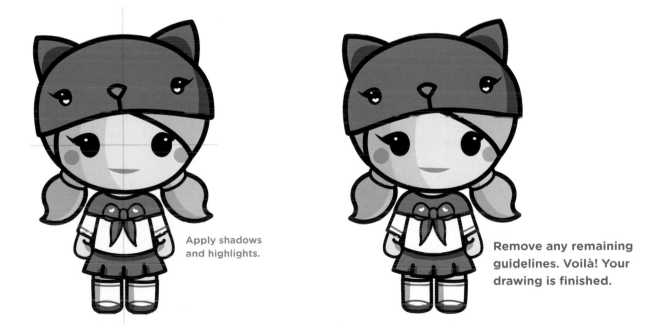

Apply shadows and highlights.

Remove any remaining guidelines. Voilà! Your drawing is finished.

positioning your characters at different angles

Because Kawaii characters are designed with such a flat look, they look best when facing forward. Most of them are drawn that way. A 3/4 view, though, is not unusual. But the profile and rearview poses are. However, never say *never*.

FRONT
Most popular angle.

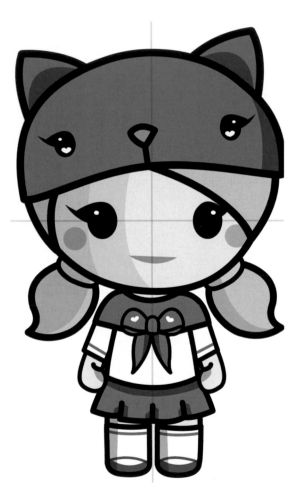

3/4 VIEW
Second-most popular angle.

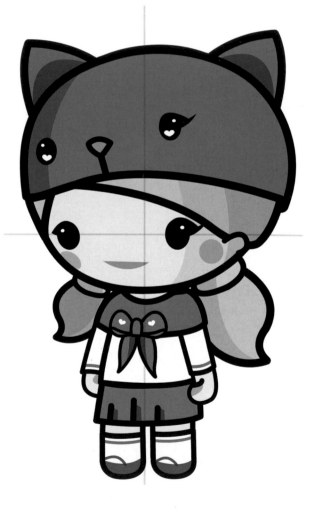

PROFILE
Avoid this if at all possible.

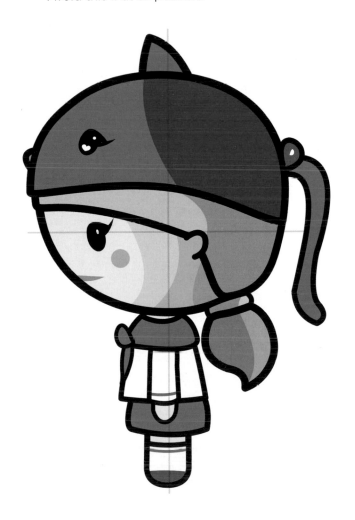

REAR
Rarely seen but cute; use it if the situation calls for it.

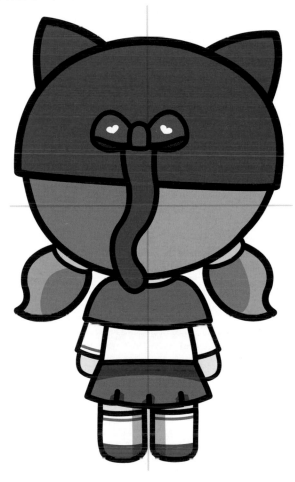

color variations

Beginners often do rough sketches before making a finished drawing. And yet, when it comes to applying colors, they usually go with their first attempt, as if they only get one bite at the apple.

Allow me to recommend the important, but greatly overlooked, process of "sketching" color roughs before deciding on a finished palette.

Here's how it's done: Make a few copies of your finished drawing. Or, if you don't have access to a copy machine, use your discarded pencil roughs. I've done that, and it works almost as well. Roughly apply a few colors to various areas. Sometimes, it only takes one or two strokes of a marker or colored pencil to envision it. At other times, you may need to color a larger area—usually when judging how several colors, placed side by side, interact with each other.

But you're not stuck choosing one approach from the three or four colored roughs you did if you don't like any of them. One technique I recommend is selecting what works from each colored rough and, from that, create one "master rough." For example, you might like the hat color on one rough you did while also liking the hair color from a different rough. This master rough incorporates the best ideas from all three of the colored roughs. If this works, then go on to complete the final, colored image. If not, then do another master rough, using different selections the next time.

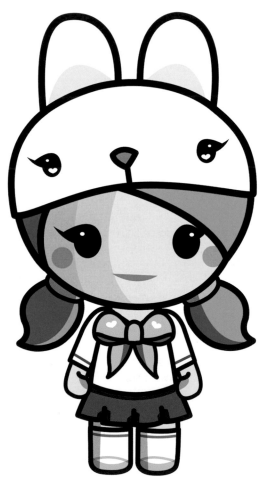

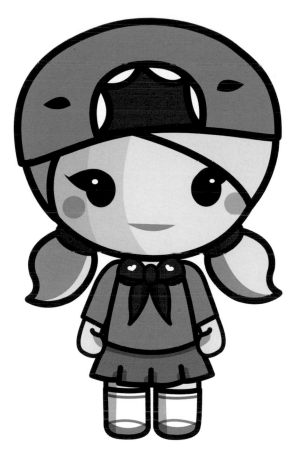 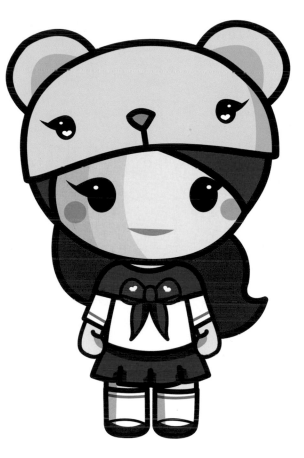

SUGGESTIONS FOR COLORING BY HAND

To create highlights, first decide what color you want the character to be. Once you've selected the color, apply a lighter tone of that color to all the places you wish to highlight. Then use the original richer color you chose for your character to color in the rest of the character, being careful not to color over the highlighted areas you just laid down. The second color you just applied is darker than the first color you used; therefore, the first color will "pop"—and serve as your highlights.

To create the shadow effects, go over the specific areas you want to shade, using a darker tone of the same color.

beginner vs. pro

By using a few simple, targeted techniques, you can produce the intended emotional response from your viewer—an irresistible desire to squeeze each character until he or she pops!

Most aspiring artists draw instinctively, which is hit or miss. Yet cute characters share specific features, which professional manga artists and animators incorporate in the initial steps of their drawings. Widely understood in the professional artists' community, these techniques have rarely been communicated to beginners. Until now.

To best illustrate these techniques, we'll look at examples of how a typical beginner might draw a Kawaii character, compared to a professional's more expressive character. Beginners, and even intermediate artists, often overlook some important opportunities. We'll point those out so that you can begin to take advantage of them.

girl with teddy bear

Though the beginner's drawing is appealing, it still has a way to go. Let's take a look at a few techniques which, when added, make the character so cute it's almost painful.

BEGINNER VERSION

PRO CONSTRUCTION

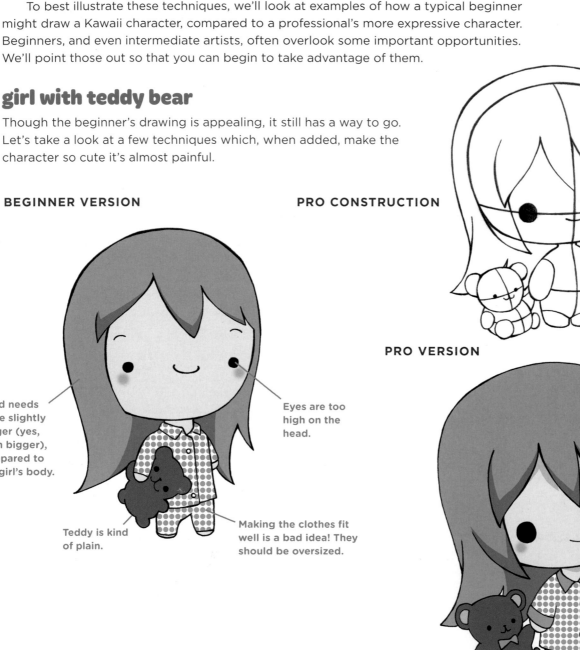

Head needs to be slightly bigger (yes, even bigger), compared to the girl's body.

Eyes are too high on the head.

Teddy is kind of plain.

Making the clothes fit well is a bad idea! They should be oversized.

PRO VERSION

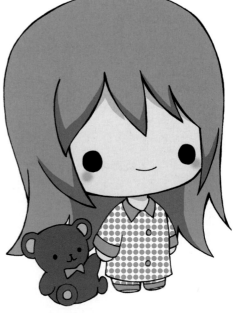

kitty-kat tyke

Pajama-type hood-to-toe "anthro" outfits always maximize cuteness. Almost by definition they do two things that make them appear sweet and charming: It makes them look younger and cuddly.

BEGINNER VERSION

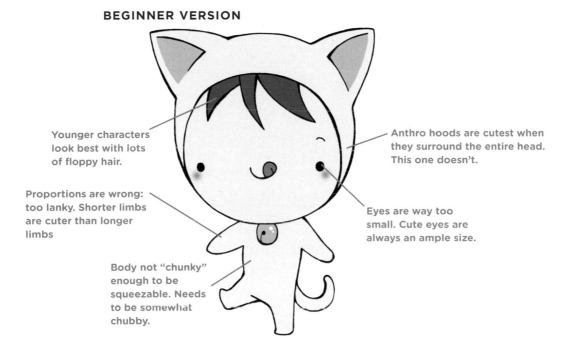

Younger characters look best with lots of floppy hair.

Proportions are wrong: too lanky. Shorter limbs are cuter than longer limbs

Body not "chunky" enough to be squeezable. Needs to be somewhat chubby.

Anthro hoods are cutest when they surround the entire head. This one doesn't.

Eyes are way too small. Cute eyes are always an ample size.

PRO CONSTRUCTION

PRO VERSION

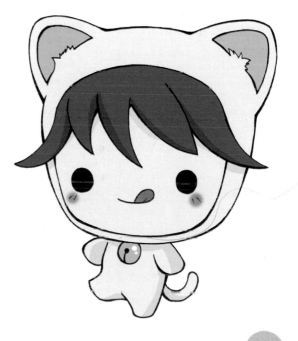

cute goths

Drawing Kawaii Goth characters is tricky. With all their dark and mean-looking elements, they can come across as repellent if you don't play it just right. Does that mean you should avoid drawing them altogether? Not at all! At the beginning, focus on laying out the "cute essentials" and proportions for these entertaining figures. If the construction is cute, then the finished version will be cute, whether it is a gothic or an innocent-looking character.

BEGINNER VERSION

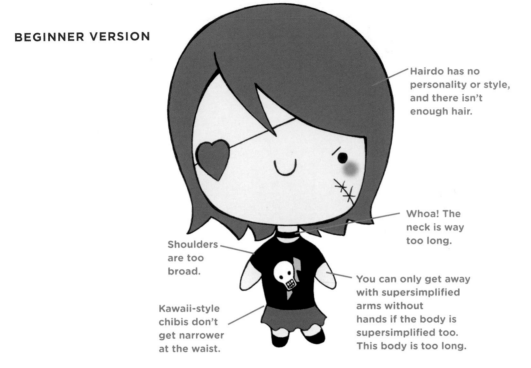

Hairdo has no personality or style, and there isn't enough hair.

Whoa! The neck is way too long.

Shoulders are too broad.

You can only get away with supersimplified arms without hands if the body is supersimplified too. This body is too long.

Kawaii-style chibis don't get narrower at the waist.

PRO CONSTRUCTION

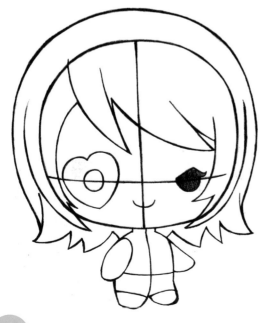

PRO VERSION

penguin with simplified shapes

Characters with bodies based on little more than simplified shapes can be ultra-adorable. They almost look like bathtub toys! Try to minimize their features, as well as their limbs, so that the cute outline shape of the character stands out. Be selective with the type of character you choose to draw with this technique. Penguins are a natural, as are pigs and elephants. But something with a more complex body type, like a horse, would not do well with a one-shape treatment.

BEGINNER VERSION

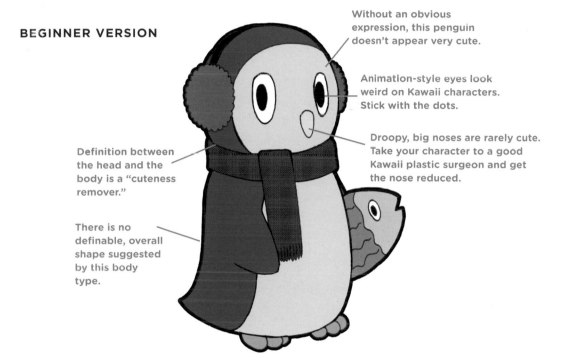

Without an obvious expression, this penguin doesn't appear very cute.

Animation-style eyes look weird on Kawaii characters. Stick with the dots.

Definition between the head and the body is a "cuteness remover."

Droopy, big noses are rarely cute. Take your character to a good Kawaii plastic surgeon and get the nose reduced.

There is no definable, overall shape suggested by this body type.

PRO CONSTRUCTION

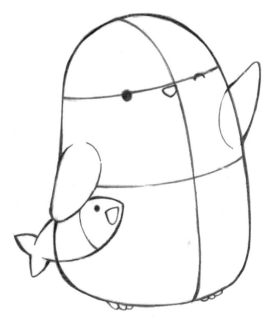

PRO VERSION

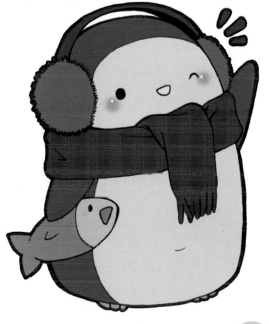

sad bunny

Some of the most sympathetic expressions are actually teary-eyed ones. They evoke heart-rending feelings. It's a great way to manipulate your viewers' emotions. Viewers are like putty in a Kawaii artist's hands. Oh, yes, we are that diabolical.

BEGINNER VERSION

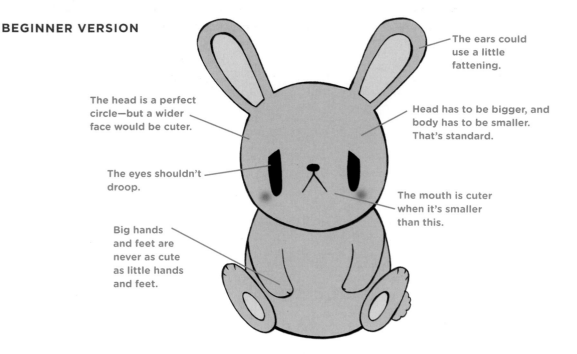

The ears could use a little fattening.

The head is a perfect circle—but a wider face would be cuter.

The eyes shouldn't droop.

Head has to be bigger, and body has to be smaller. That's standard.

The mouth is cuter when it's smaller than this.

Big hands and feet are never as cute as little hands and feet.

PRO CONSTRUCTION

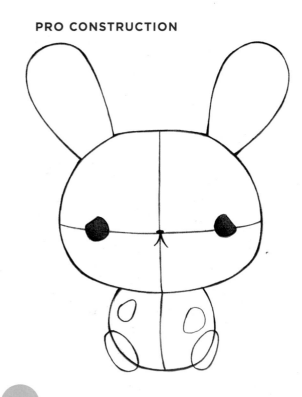

PRO VERSION

basket of pups and friends

The difference between a drawing that's adequate and a drawing dripping with cuteness is often just a matter of a few small tweaks; however, don't underestimate the effect that an accumulation of small changes has on a drawing. The difference that you see between the example of the Beginner Version below and the corresponding Professional Version is due to a combination of subtle adjustments, which, when taken together, add up to a significant improvement. That's one of the main differences between a beginner and a pro: The pro will make adjustments to small inconsistencies in his drawings, whereas the beginner is more likely to adjust only the prominent mistakes. So get in there, and have fun working on the details too.

BEGINNER VERSION

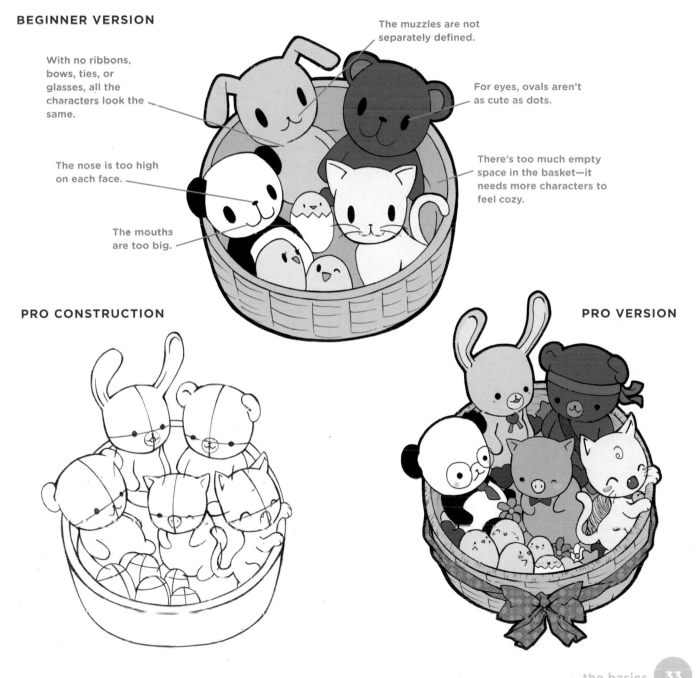

The muzzles are not separately defined.

With no ribbons, bows, ties, or glasses, all the characters look the same.

For eyes, ovals aren't as cute as dots.

The nose is too high on each face.

There's too much empty space in the basket—it needs more characters to feel cozy.

The mouths are too big.

PRO CONSTRUCTION

PRO VERSION

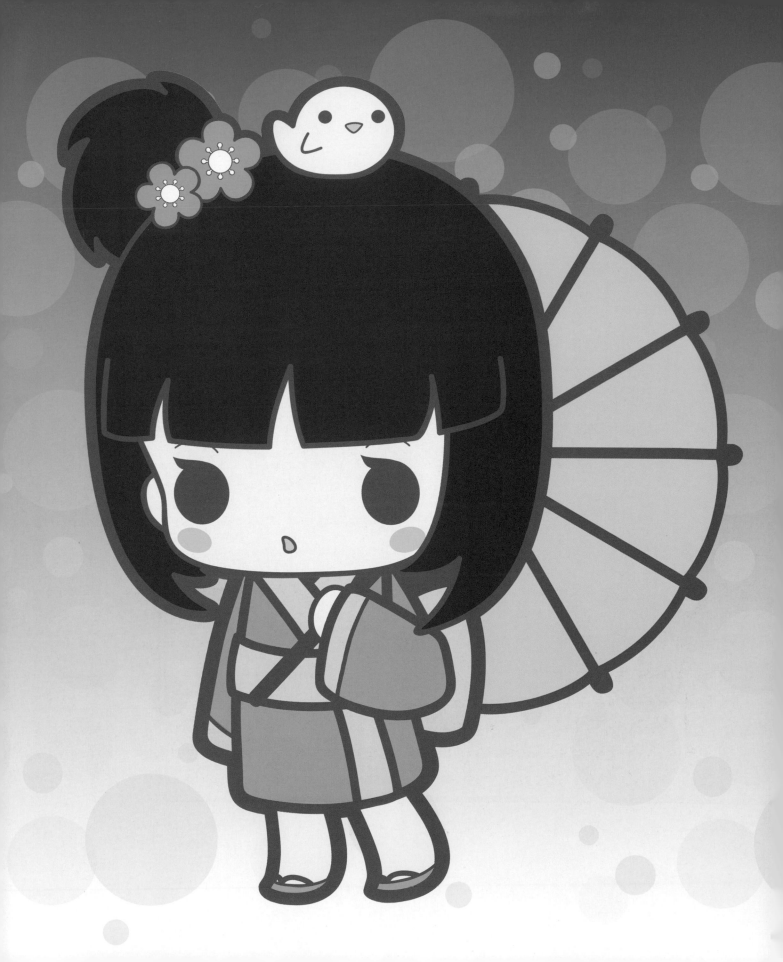

essential kawaii character types

To create an appealing, effective character, it sometimes helps to pause a moment before you draw and try to envision the final result. Each character requires resourceful imagination and creativity to bring it to fruition. Like all other manga genres, certain character types stand out as "staples." These are the popular characters that fans expect to see and look forward to seeing. The Kawaii genre has been built, to some extent, around these essential characters. Therefore, it's important to begin with an overview of these popular Kawaii stars. This important chapter covers a bunch of popular character types; then the rest of the book will go into detail on these types and present many more!

cute girls

Cute girls come in all character types and costumes. They can be schoolgirls, magical girls, princesses, or kimono girls, like this one. The basic body shape is similar. Therefore, hairstyle, costume, accessories, expression, and the degree of glamour and style you infuse into the drawing will give your character a uniquely appealing look.

Even though the foundation of the character is built with round shapes and curved lines, the superthick outline that surrounds her creates a distinctly flat, graphic look.

The proportions are also uniquely Kawaii: Her head is as tall as her body is long! And her eyes, which don't have the classic "eye-shines" characteristic of all other genres of manga, are superwide apart, which is typical of Kawaii characters.

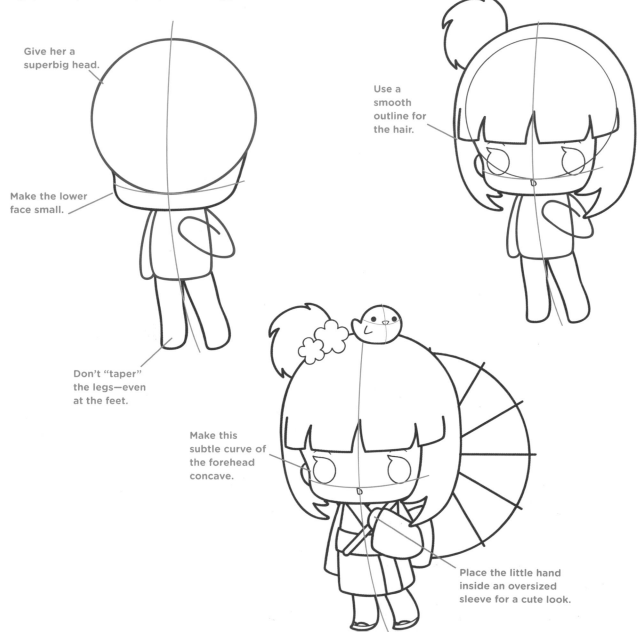

Give her a superbig head.

Make the lower face small.

Don't "taper" the legs—even at the feet.

Use a smooth outline for the hair.

Make this subtle curve of the forehead concave.

Place the little hand inside an oversized sleeve for a cute look.

Add pretty accessories, without too much detail.

The simple character design allows the colors to work. More detail would clutter the body with thick ink lines, and the color would take a back seat. Kimonos are usually deep red, which would be a pretty bold choice for such a sweet and charming character. So the classic red has been kept but softened to a rose color.

cat girls and anthros

Cat girls and anthros, which are popular ancillary characters in many genres of manga, are Kawaii mainstays. Put a cat-girl hood on a Kawaii character and readers will squeal.

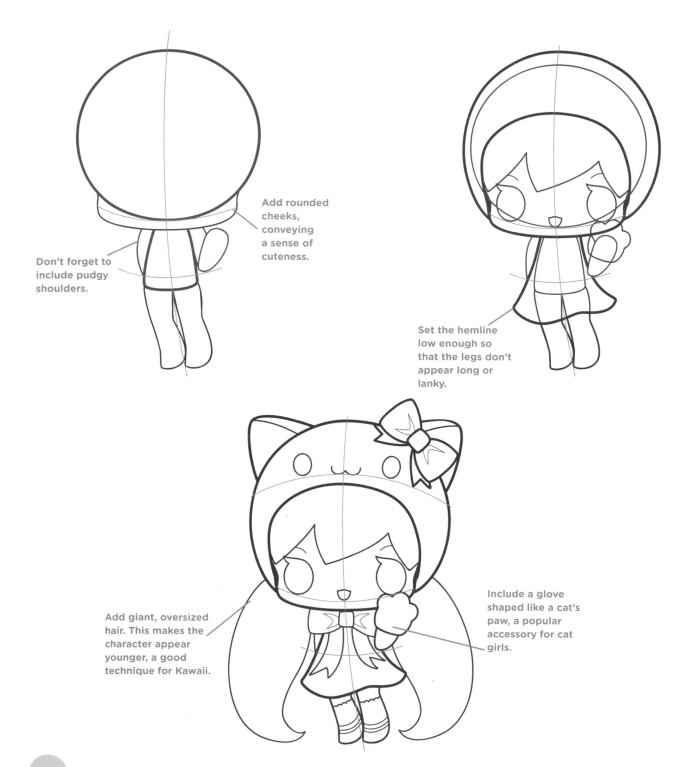

Add rounded cheeks, conveying a sense of cuteness.

Don't forget to include pudgy shoulders.

Set the hemline low enough so that the legs don't appear long or lanky.

Add giant, oversized hair. This makes the character appear younger, a good technique for Kawaii.

Include a glove shaped like a cat's paw, a popular accessory for cat girls.

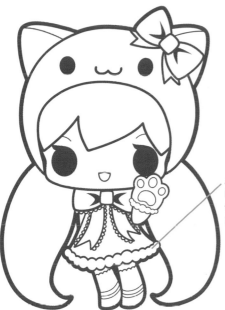

Add some lace and bows—but not so many that it makes the overall image look "busy."

You can even give the anthro blush marks on its cheeks.

animal cuties

These ultrasqueezable critters are soooo popular. And it's easy to see why. They're like living plush dolls. You just want to hug them so tight until stuffing pops out of their insides, which would leave them looking like charming versions of roadkill.

Kawaii animals resemble the real animal on which they're based only in the loosest way. The style comes first, then the animal traits are incorporated, which is the opposite of how most approaches to drawing work. But then, Kawaii is one of the most style-heavy genres of art there is.

The panda is the quintessential Kawaii animal—a total cutie, with Asian credentials. Using a minimum of detail, its markings make it immediately recognizable.

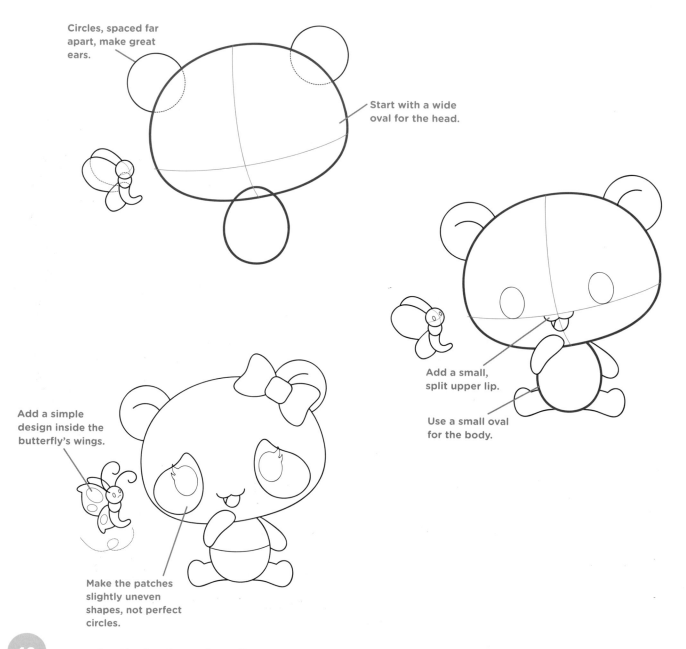

Circles, spaced far apart, make great ears.

Start with a wide oval for the head.

Add a small, split upper lip.

Use a small oval for the body.

Add a simple design inside the butterfly's wings.

Make the patches slightly uneven shapes, not perfect circles.

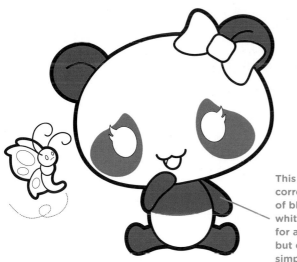

This is actually the correct application of black-and-white markings for a real panda but executed in a simplified manner.

A few colorful accents are all that are required to add some zing to this mainly gray and white image.

fantasy creatures and pets

These fun-loving buddies are often based on dinosaurs, other animals, and, sometimes, even abstract shapes. Fantasy pets can even own smaller fantasy pets. I guess the little fantasy pet could own an even smaller fantasy pet!

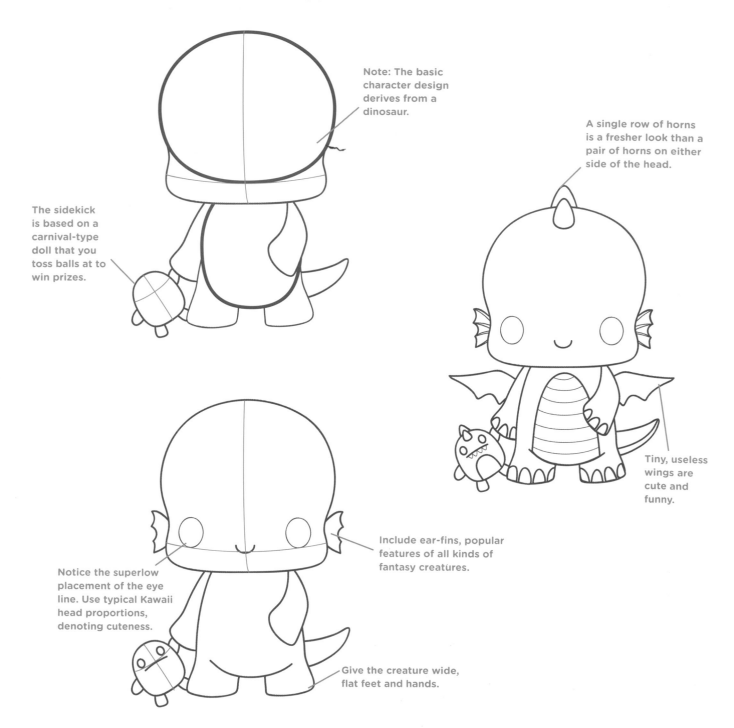

Note: The basic character design derives from a dinosaur.

The sidekick is based on a carnival-type doll that you toss balls at to win prizes.

A single row of horns is a fresher look than a pair of horns on either side of the head.

Tiny, useless wings are cute and funny.

Notice the superlow placement of the eye line. Use typical Kawaii head proportions, denoting cuteness.

Include ear-fins, popular features of all kinds of fantasy creatures.

Give the creature wide, flat feet and hands.

Choose a cheerful color as the main theme for your character. Lime-green, blue, pale pink, and orange are among the more popular ones.

Small accents with lively colors enliven the image. Note the yellow coloring for the creature's nails. If they were colored white, it might look like a mistake, as if the color had been accidentally dropped out.

food and treats with personality

Candy and treats are a massively popular subset of Kawaii. Each sweet treat has its own joyful personality. It's totally happy and enchanting. In this example, each ice cream face has a different personality and expression. The dish has a touch of Old World charm. And the chocolate syrup is poured over the scoops so that the syrup appears to be worn as gooey headwear!

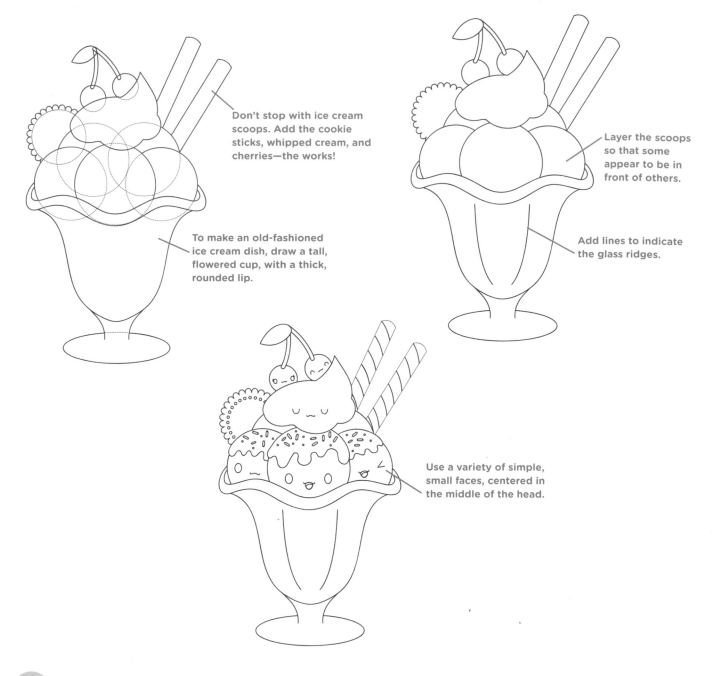

Don't stop with ice cream scoops. Add the cookie sticks, whipped cream, and cherries—the works!

To make an old-fashioned ice cream dish, draw a tall, flowered cup, with a thick, rounded lip.

Layer the scoops so that some appear to be in front of others.

Add lines to indicate the glass ridges.

Use a variety of simple, small faces, centered in the middle of the head.

Draw faces on even the tiny cherries!

The dollop of whipped cream comes to a point at the tip.

Don't forget to give all the elements fun little details, like stripes and patterns.

Even though glass has no color, add some to liven it up. Blue is often used to color in glass objects.

gothic cuties

You've seen Goths in various manga genres: Gloomy. Brooding. Rebellious. Okay, now look at the Kawaii Goth. Her outfit may say "antisocial," but her character design says "hug me." There are two, strong visual themes here: Kawaii cuteness and gothic darkness. In combination, the cuteness is actually highlighted against the backdrop of gothic darkness, instead of being diminished by it. This is a great example of contrast.

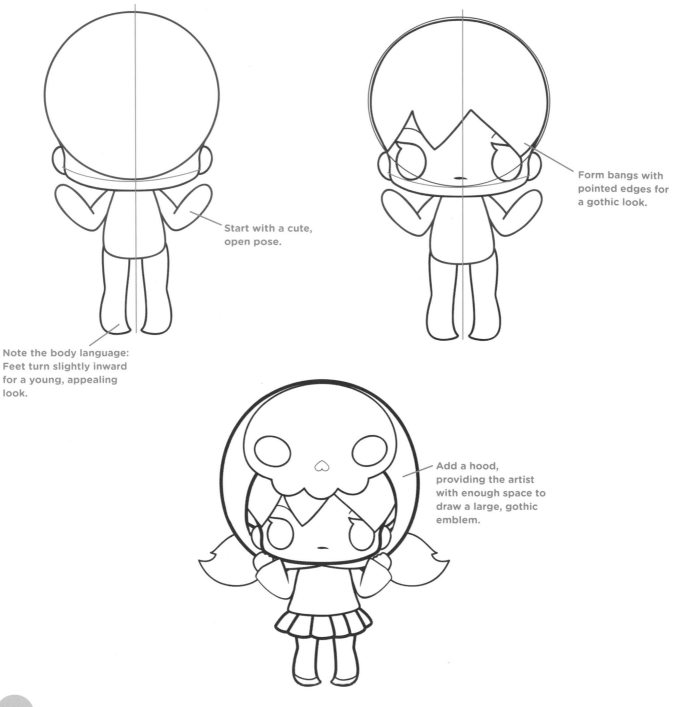

Start with a cute, open pose.

Form bangs with pointed edges for a gothic look.

Note the body language: Feet turn slightly inward for a young, appealing look.

Add a hood, providing the artist with enough space to draw a large, gothic emblem.

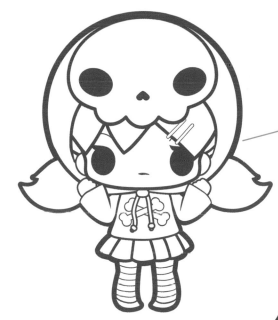

Note that though gothic characters wear all sorts of evil costumes and emblems, their proportions are the same as those of cute characters.

The palette may be varied, but the colors are all along the spectrum of nighttime colors, in order for the character to be a Goth.

hamster boy

The typical anthro hood surrounds the entire head, with an opening for the face. This circular opening emphasizes the roundness, which conveys cuteness. Can't get too much cuteness. (Some anthro hood variations don't surround the entire head. We'll see some of those examples later in this section.)

Notice that there's even an expression on the hood's face! And it doesn't necessarily have to match the expression on the wearer's face. It can, but it's also fun to give the animal hood a mind of its own. The oversized hood also has the effect of bumping up the size of the head, which keeps the character looking young.

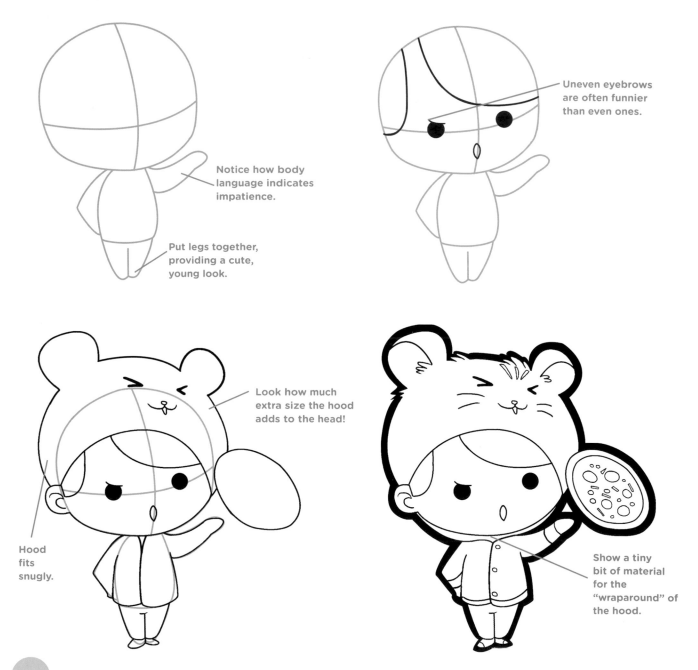

Notice how body language indicates impatience.

Put legs together, providing a cute, young look.

Uneven eyebrows are often funnier than even ones.

Look how much extra size the hood adds to the head!

Hood fits snugly.

Show a tiny bit of material for the "wraparound" of the hood.

When drawing a Kawaii character, don't try to accomplish too much with the pose. These are cute, chubby, little tykes. Action poses aren't necessary and can even detract from their almost incomprehensible dearness.

hamster girl

For variety, this time we use a hat instead of a hood! Not only that but the hamster on the hat looks less like a real hamster than the one on Hamster Boy. It's just as cute and funny, but the design and colors are more whimsical and fanciful. It's just another approach. You don't have to be literal in the Kawaii style. *Cute* is more important than *realism*!

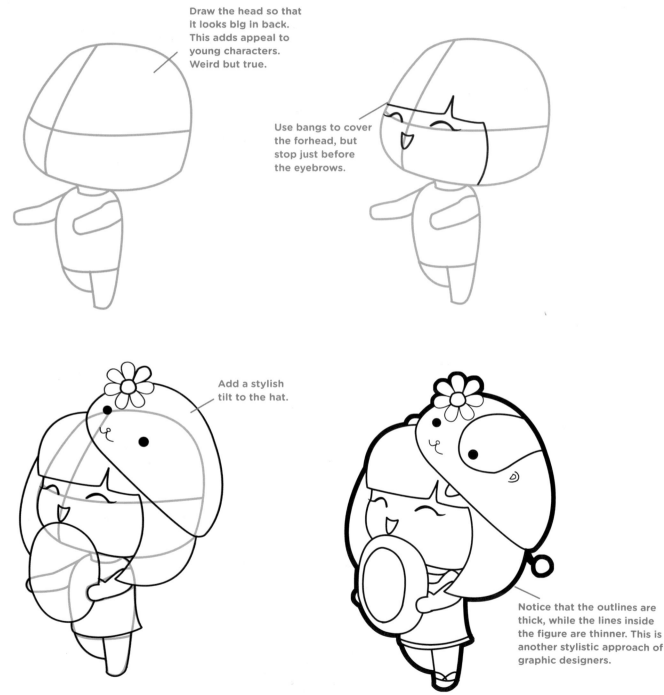

Draw the head so that it looks big in back. This adds appeal to young characters. Weird but true.

Use bangs to cover the forhead, but stop just before the eyebrows.

Add a stylish tilt to the hat.

Notice that the outlines are thick, while the lines inside the figure are thinner. This is another stylistic approach of graphic designers.

QUICK TIP
Kawaii girl and boy characters generally have similar body types—pudgy!

Note the cute accents: The blush marks aren't soft and subtle but are funny, solid, pink ovals.

tiger boy

Tiger Boy is a good example of a third approach to creating cute anthros. This is a good example of a full head-to-body costume. The hood and bodysuit are part of the same outfit; they never come à la carte. Note that the muzzle of the tiger dips below the hood, breaking the circular outline. This technique makes the hood stand out. The anthro character is often drawn to reflect the personality traits of the human who wears it, in this case producing an aggressive and bossy tiger.

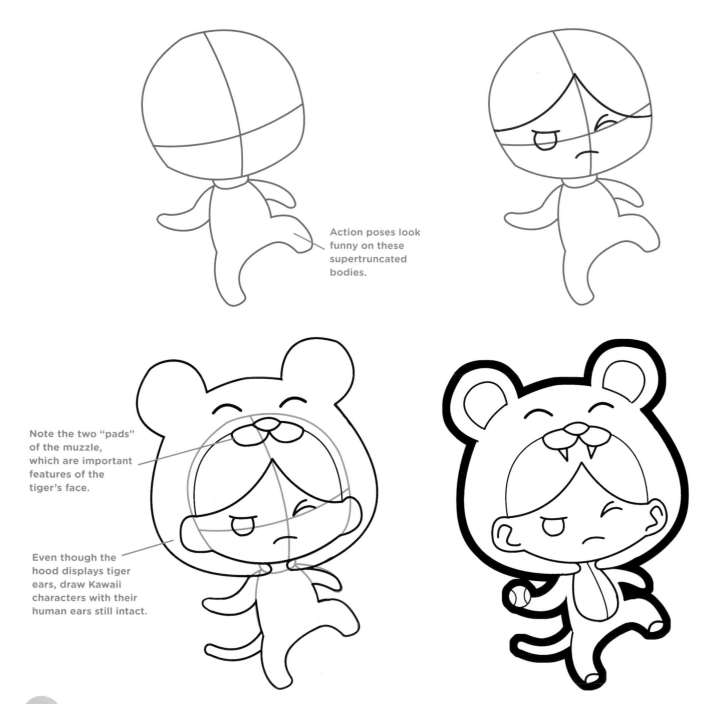

Action poses look funny on these supertruncated bodies.

Note the two "pads" of the muzzle, which are important features of the tiger's face.

Even though the hood displays tiger ears, draw Kawaii characters with their human ears still intact.

Add stripes so that people know this is a tiger. Orange and black provide a standout color combination that commands attention.

tiger girl

The pinks, reds, and grays of this anthro work in a cool pattern. Hats have another advantage over hoods for girl characters. A hood covers the entire head, hiding the hair. A hat allows the hair to unfurl. Look at the funny duality of expressions: She's having a rockin' good time, while the kitty is fast asleep on top of her head.

Convey a feeling of intense joy by combining closed eyes with an open-mouthed smile.

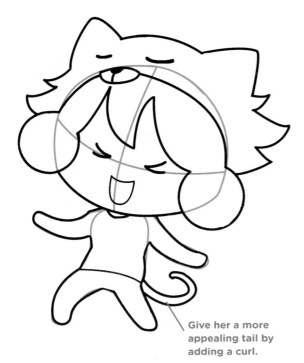

Give her a more appealing tail by adding a curl.

When inventing a fun prop, make it relate to the character. Here's a giant cat's paw.

You don't have to use the exact color scheme of a real tiger. If you become adventurous with the costume design, you can also become experimental with the color palette.

wolf boy

Sometimes, a little Kawaii character is drawn to look perfectly normal, even preppy, or sporty and fashionable. There's only one teeny little thing that's out of place: He's wearing a huge animal on his head. Why this works, and how this all got started, few people really know; and those who do aren't telling. But for these purposes, all you really need to know is that it's a superpopular look that adds character and charm to regular Kawaii characters.

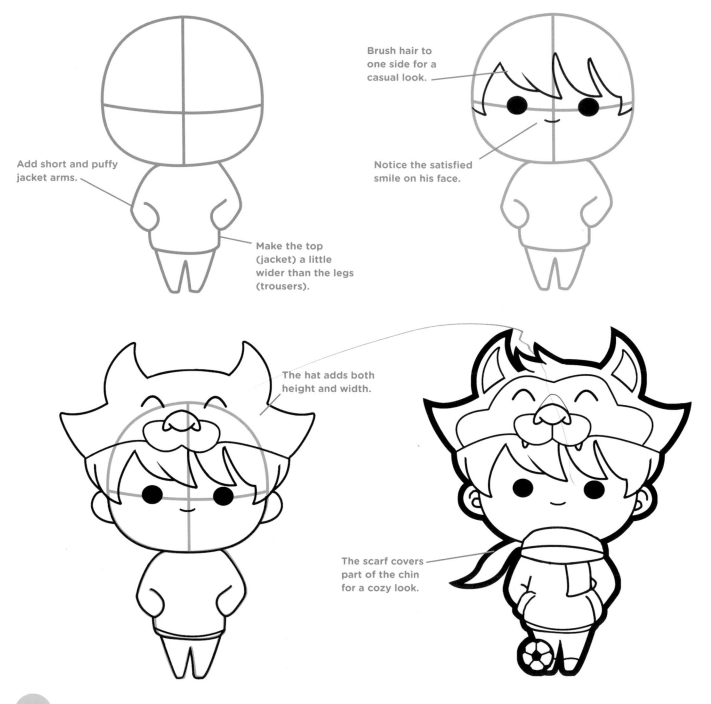

Add short and puffy jacket arms.

Make the top (jacket) a little wider than the legs (trousers).

Brush hair to one side for a casual look.

Notice the satisfied smile on his face.

The hat adds both height and width.

The scarf covers part of the chin for a cozy look.

The somewhat muted colors give the reserved little character a sense of cute dignity.

wolf girl

Remember that we said that hoods are often difficult items for female characters, because they hide their long hair? Well, look how inventively that problem was solved here: The pink fur that surrounds her head is ruffled so that the hood actually gives the appearance of hair. And that's what keeps her looking so feminine.

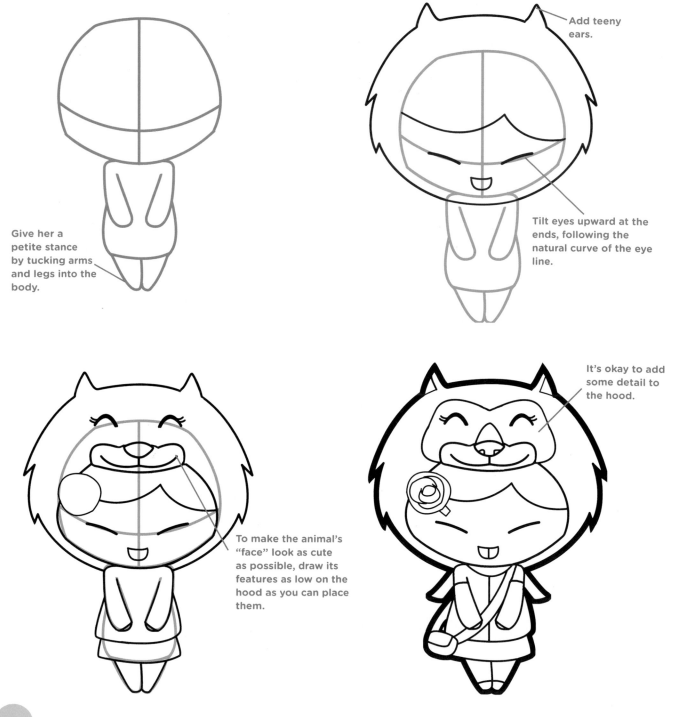

Give her a petite stance by tucking arms and legs into the body.

Add teeny ears.

Tilt eyes upward at the ends, following the natural curve of the eye line.

To make the animal's "face" look as cute as possible, draw its features as low on the hood as you can place them.

It's okay to add some detail to the hood.

Many beginning artists believe that they shouldn't put different shades of the same colors side by side, because it won't make for enough contrast. As you can see by this Kawaii girl's example, contrast should not be the sole deciding factor. Sometimes, using several shades of the same color is a very stylish choice.

panda tyke

Anthro hoods and hats can be based on any animal. But don't forget the Japanese classic: the panda bear. In addition to its classic cuteness, there's also an artistic reason the panda works well as an anthro character. The panda's naturally large and round head maintains its shape, even when transformed into a hood. The black-and-white markings are clear and high-contrast, and instantly telegraph the identity of the animal.

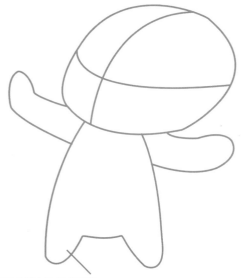

Spread the legs apart—give him the posture of a character standing his ground.

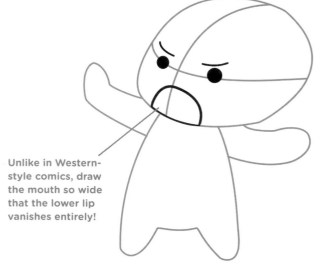

Unlike in Western-style comics, draw the mouth so wide that the lower lip vanishes entirely!

By not tying the bottom of the hood you reveal more of the face.

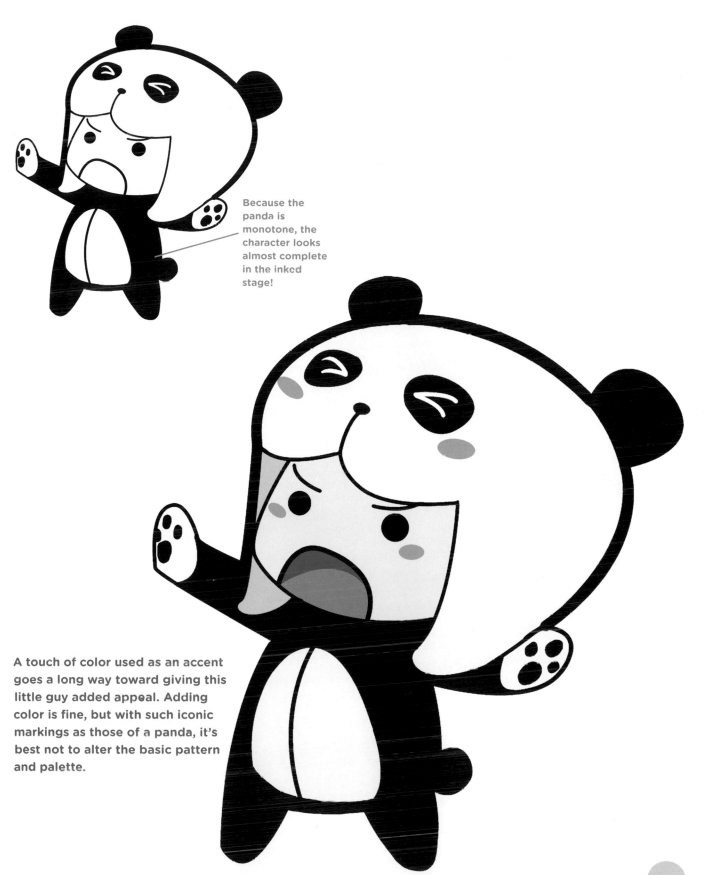

Because the panda is monotone, the character looks almost complete in the inked stage!

A touch of color used as an accent goes a long way toward giving this little guy added appeal. Adding color is fine, but with such iconic markings as those of a panda, it's best not to alter the basic pattern and palette.

humorous panda

Most of the time, anthro hats and hoods are worn like clothing—characters don't acknowledge them or interact with them. But anthro hoods are also used to create humorous situations. One approach is to give your hood personality, a mind of its own. For example, the panda hood could be continually slipping over the boy's face, as it does here. Or it could be mean, squeezing the boy's head and not letting go. Maybe it makes fun of the boy, by making goofy faces out of eyeshot when he's talking. You can easily make up some of your own humorous scenarios. The main element in all these situations is that the hood takes on a life of its own.

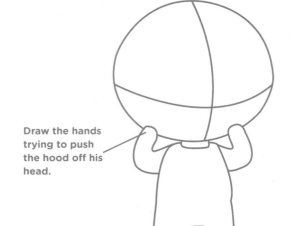

Draw the hands trying to push the hood off his head.

Form a surprised expression by using a tiny circle or oval as a mouth.

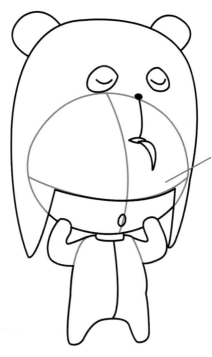

Draw this funny hood as a "ginormous" head—so big, it even covers the kid's eyes!

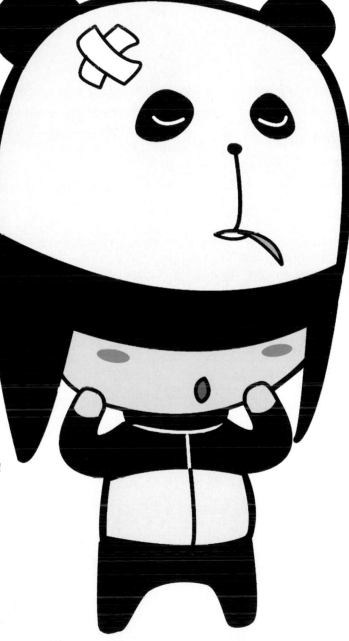

"Checkerboard" the blacks against the whites so that each stands out against the other.

Only a touch of skin color is required for contrast to show that there's a head stuck under that hood!

deer boy

Previously, you may not have thought of animal hoods with antlers. Until now, you may not have thought of animal hoods at all. But you're in the big leagues now.

The key to drawing Kawaii-style antlers is to make them small and rounded, rather than sharp and long. Real deer have angular faces—even baby deer. So how do you maintain the deer's head shape, while transforming it into a hood? The short answer is, you can't. It would end up looking boxy, and that's not cute. Instead, you'll have to invent a fun and imaginative version of a deer. It's good that we have those antlers, because they're an important visual marker—they communicate to the reader that this is, in fact, a deer.

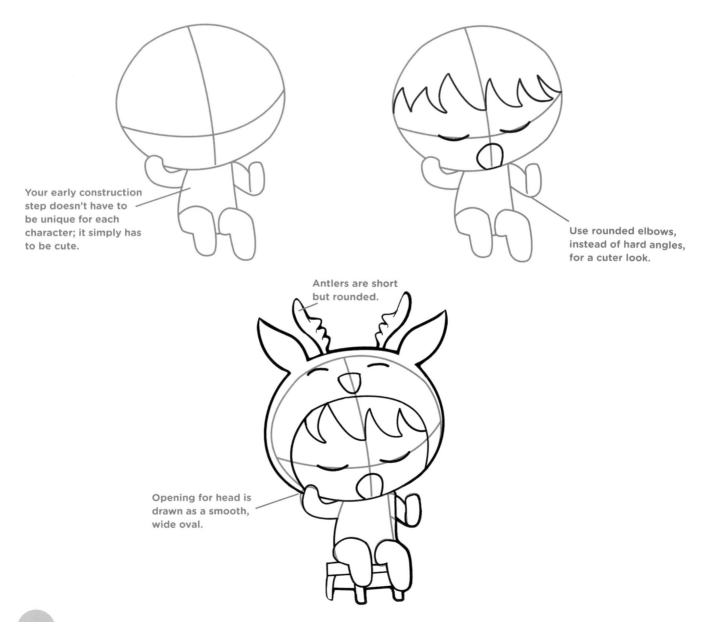

Your early construction step doesn't have to be unique for each character; it simply has to be cute.

Use rounded elbows, instead of hard angles, for a cuter look.

Antlers are short but rounded.

Opening for head is drawn as a smooth, wide oval.

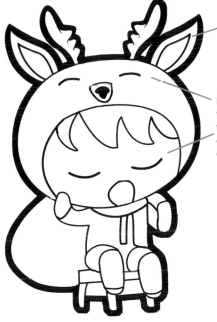

Notice the classic deer-type ears.

Both the boy's face and the deer's face have their eyes closed—two characters in sync.

Note that Kawaii expressions can be quite minimal and still retain the character's personality. For example, this little guy has no eyebrows—and doesn't need them!

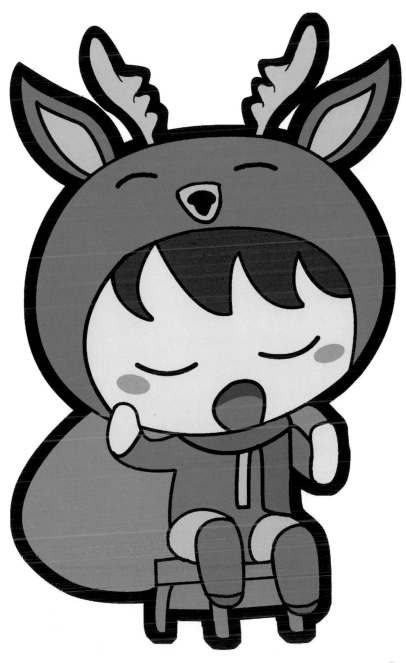

deer girl

How simplified can an anthro costume be and still be considered an anthro, rather than a cute Kawaii character wearing an adorable little hat? This picture pretty much illustrates that threshold. This deer hat has eyes, nose, ears, and antlers, but they've been so minimized that they hardly register. If I hadn't told you it was a deer, would you have been able to guess? Then again, would it matter? As long as it's cute—and it is—the character is a winner. The main thing to keep in mind is that an anthro-style hat can't be small and petite. It has to be sizable, encompassing a large area, and with an obvious animal derivation. The animal ears and horns on this hood fulfill that requirement.

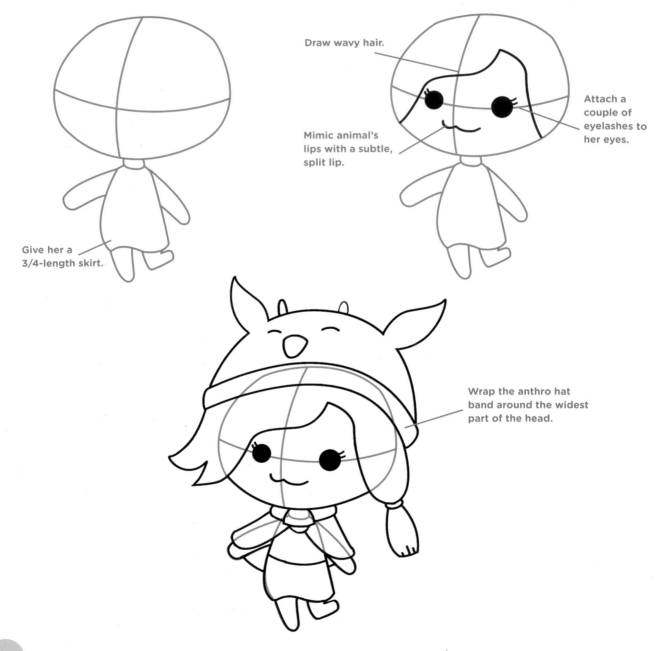

Give her a 3/4-length skirt.

Draw wavy hair.

Mimic animal's lips with a subtle, split lip.

Attach a couple of eyelashes to her eyes.

Wrap the anthro hat band around the widest part of the head.

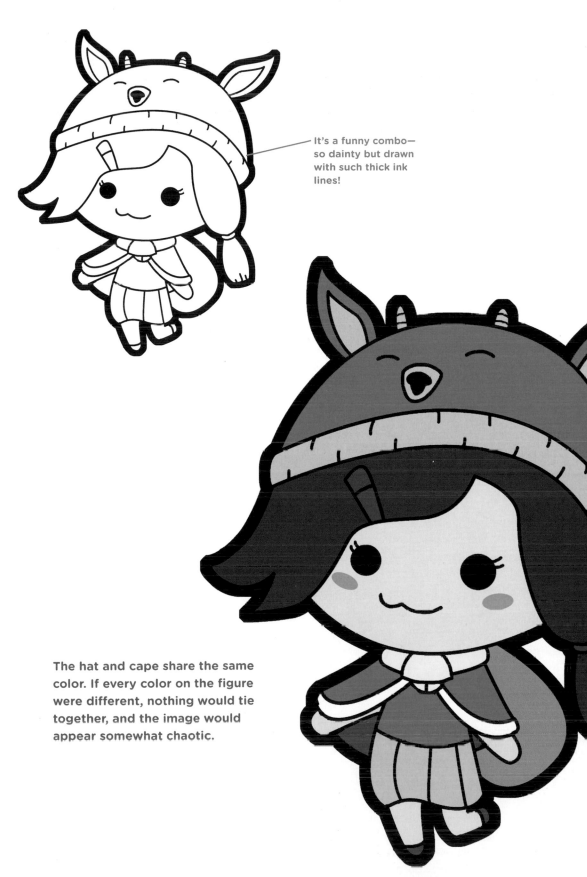

It's a funny combo—
so dainty but drawn
with such thick ink
lines!

The hat and cape share the same
color. If every color on the figure
were different, nothing would tie
together, and the image would
appear somewhat chaotic.

trendy rabbit

A cute hood can actually be used as a fashion accessory, just like a purse, shoes, or a scarf. So add a bow, flower, scrunchy, or headband to the hood. Make sure the colors match the outfit. In cases like this, where the hood serves as clothing and not as an alter ego, draw the hood character's eyes closed to keep its personality subdued.

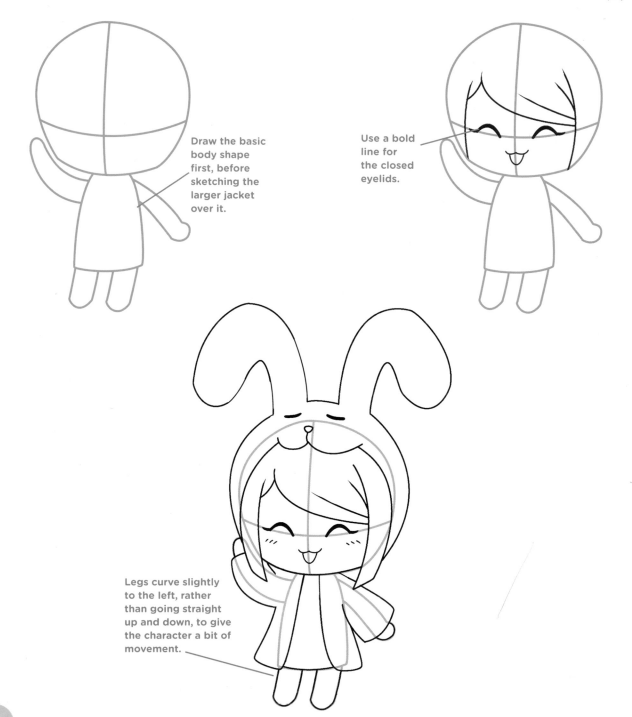

Draw the basic body shape first, before sketching the larger jacket over it.

Use a bold line for the closed eyelids.

Legs curve slightly to the left, rather than going straight up and down, to give the character a bit of movement.

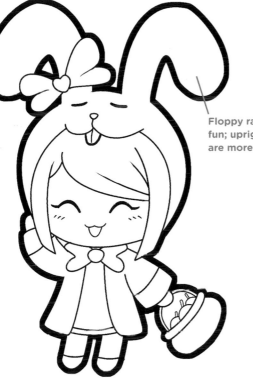

Floppy rabbit ears are fun; upright rabbit ears are more realistic.

QUICK TIP

Many different color options go with white. Most people don't think of it, but white is a very versatile color.

No pockets, no buckles, no buttons. But just keeping it simple isn't enough—your character also has to have the right style.

pirate rabbit

Here's an example of a hood that is smaller than the head of the character wearing it. As a result, his hair sticks out on either side of the hood. The hood flaps dangle at the sides of his head, unless you connect them below his chin. Personally, I prefer hoods that surround the entire head. But this technique has a playfully silly look to it, which can add variety to a cast of anthro characters.

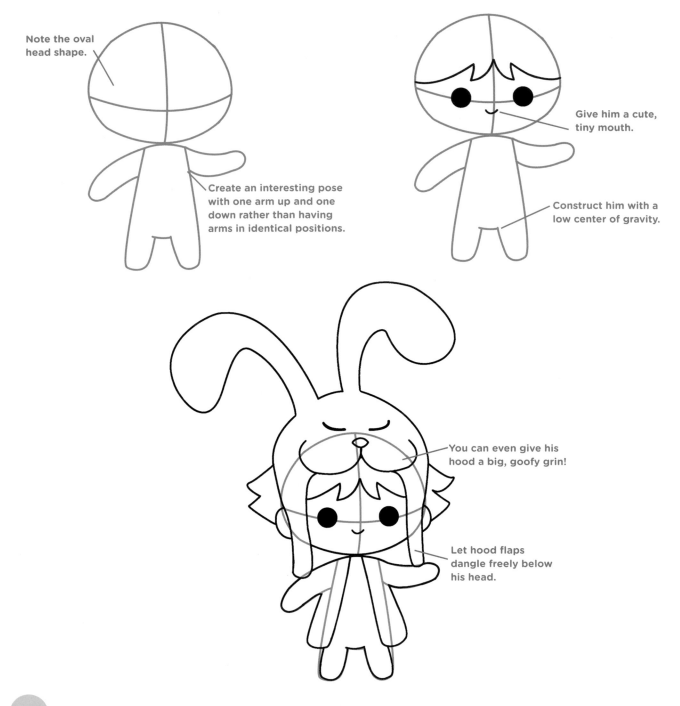

Note the oval head shape.

Create an interesting pose with one arm up and one down rather than having arms in identical positions.

Give him a cute, tiny mouth.

Construct him with a low center of gravity.

You can even give his hood a big, goofy grin!

Let hood flaps dangle freely below his head.

Add a prop that relates to the character.

The natural colors for bunnies are white, gray, and brown. The more popular whimsical colors are pink, light blue, and sometimes yellow.

goth with bat wings

Got a Goth? Then you'll want to give it a standout icon or accessory to make a splash. Try bat wings. They're cool and stylish—and they immediately convey darkness.

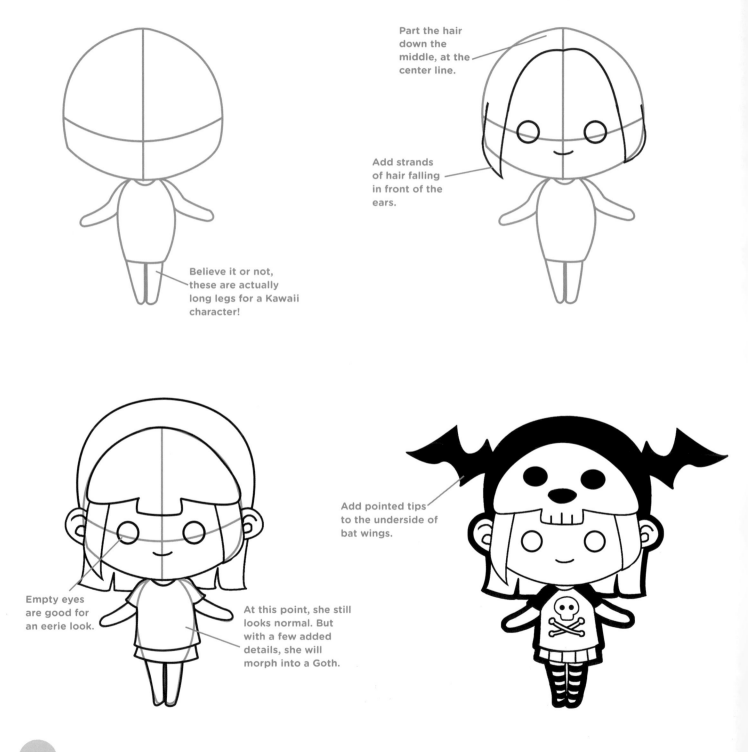

Believe it or not, these are actually long legs for a Kawaii character!

Part the hair down the middle, at the center line.

Add strands of hair falling in front of the ears.

Empty eyes are good for an eerie look.

At this point, she still looks normal. But with a few added details, she will morph into a Goth.

Add pointed tips to the underside of bat wings.

Gray isn't usually used for Kawaii characters, because it's not so buoyant. But it works well for Goths, in combination with other colors, such as black, red, lavender, pink, pale green, yellow, and purple.

CREATING GOTH ANTHROS

Because Goths are such a popular part of Kawaii, they make an essential addition to our cast of hooded characters. These mixed-genre anthros are particularly entertaining—and popular with readers.

Combine several of the strongest visual elements from Goth and anthro to create an effective, mixed genre. For Goth, any of the following make good choices: skulls, bones, wings, spikes, chains, stitched scars, and a scythe. For anthros, choose from this select group: bats, black cats, snakes, spiders, wolves, crows, rats, toads, owls, dragons, and scorpions.

goth with cat ears

Notice how the skull design is positioned as part of the hood—as if it were almost framed by it. Drawn in this way, the outline of the character's head is uninterrupted by the shape of the skull. It remains a smooth and stylish line, which is pleasing to the eye.

You see all the gothic stuff, but you might also be wondering, "Where are all the anthro elements?" Well, the cat ears are it. This is a technique called *selective emphasis*, which means you choose one theme to override another. In this case, the gothic genre leads and the anthro theme trails behind. You could reverse it by replacing the hood skull with a black panther's head with its own set of eyes, nose, and mouth, for example. That would switch the emphasis back to anthros.

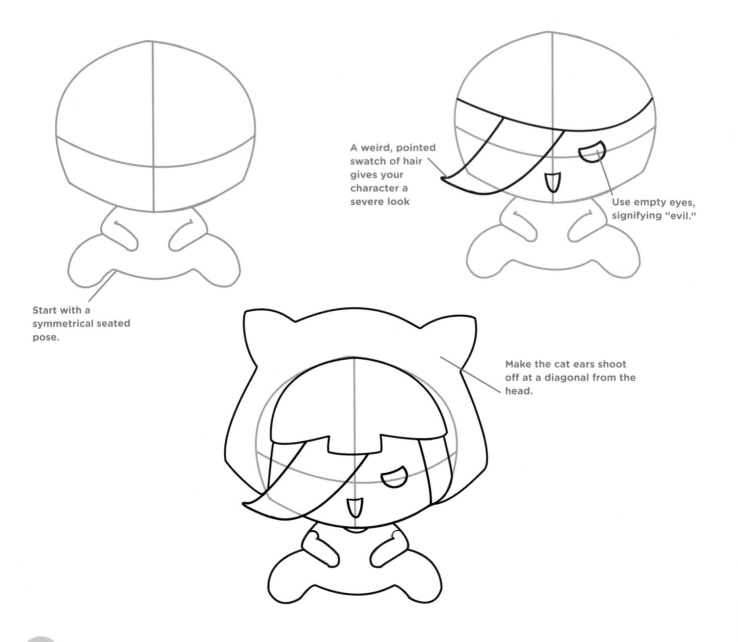

Start with a symmetrical seated pose.

A weird, pointed swatch of hair gives your character a severe look

Use empty eyes, signifying "evil."

Make the cat ears shoot off at a diagonal from the head.

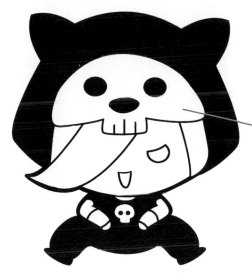

Simplify the Kawaii skull, omitting the jaw entirely.

Certain colors complement black particularly well. These include red, yellow, pink, and purple; however, be careful using a dark purple right next to black. That may be hard to read, because they're both dark.

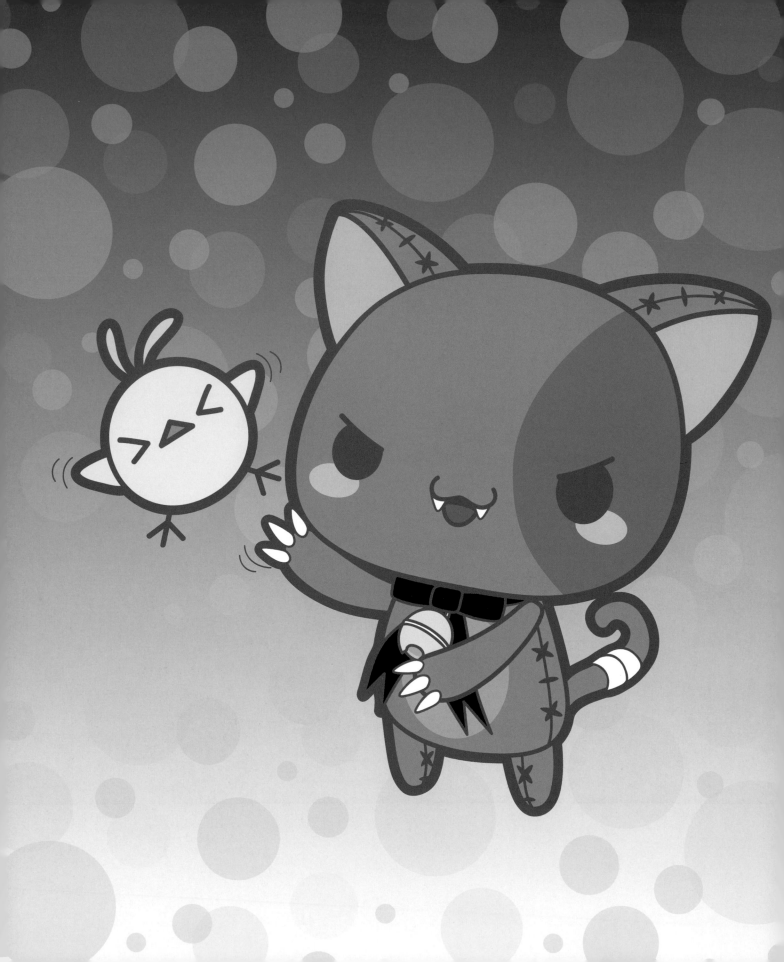

the dark side of kawaii

Dark characters are a gigantic fan fave among Kawaii lovers. This is the edgy side of cute. They're not your mom's idea of cute and cuddly—that's for sure!

Humor is an essential part of Kawaii. And these characters provide the laughs. Their personalities are so bad, so unredeeming, so antisocial that they become perplexingly irresistible. They get this appeal, in part, from their intensity. So much force, emanating from such a little container, makes for a silly, visual contradiction. You can't help but find it funny!

evil dolls

Evil cute dolls are a new trend in Kawaii that is growing in popularity. These characters are so evil, so diabolical that it's imperative you turn your eyes away and not give in to their cuteness. Hmm. I can see from your expression that it's too late. You've already succumbed.

Their oversized stitching, plus a raggedy or damaged appearance, are the key elements of these dolls. Sinister expressions, eye patches, fangs, claws, bandages, and gothic attire all convey wickedness that knows no bounds.

bad teddy

Everyone loves teddy bears. But everyone has seen them dozens of times, so it's time to reinvent the character. Welcome to my teddy-bear nightmare.

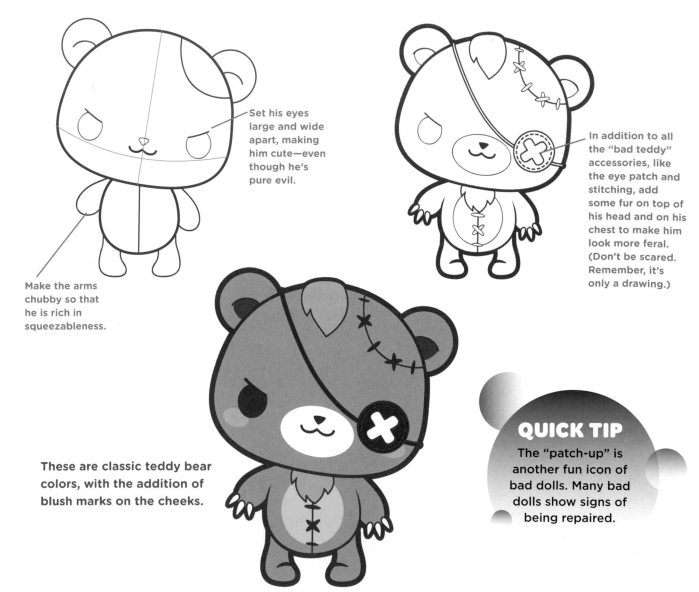

Set his eyes large and wide apart, making him cute—even though he's pure evil.

Make the arms chubby so that he is rich in squeezableness.

In addition to all the "bad teddy" accessories, like the eye patch and stitching, add some fur on top of his head and on his chest to make him look more feral. (Don't be scared. Remember, it's only a drawing.)

These are classic teddy bear colors, with the addition of blush marks on the cheeks.

QUICK TIP

The "patch-up" is another fun icon of bad dolls. Many bad dolls show signs of being repaired.

gothic doll

Gothic dolls are toys that take after their evil owners in both personality and form. They are weirdly charming—cute but deadly.

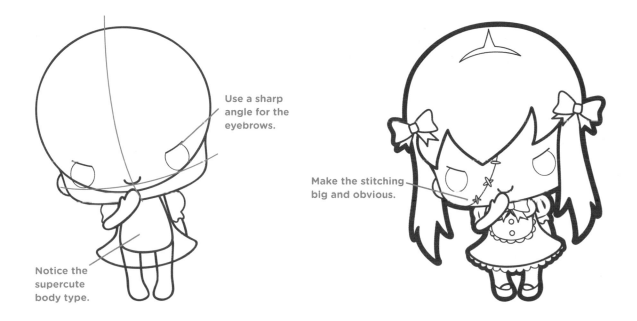

Use a sharp angle for the eyebrows.

Make the stitching big and obvious.

Notice the supercute body type.

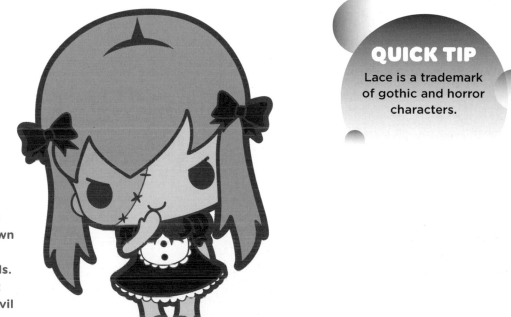

The two tones of the face indicate that she was damaged and sewn back together from two different materials. There's no doubt that she's a doll—and an evil one at that!

QUICK TIP

Lace is a trademark of gothic and horror characters.

evil bunny

Do not—I repeat—*do not* pet this rabbit.

If you want to draw a really funny evil doll, don't forget about the fluffy ones. The fluffier they are, the funnier they are with a cruel expression. To top it off, he has a bite mark on his ear, where a piece went missing. Probably happened as a result of an argument with the Bad Teddy from page 80.

Teensy fangs are humorous, because they're so ineffective. Oh, look: Someone put a bow on him. How sweet.

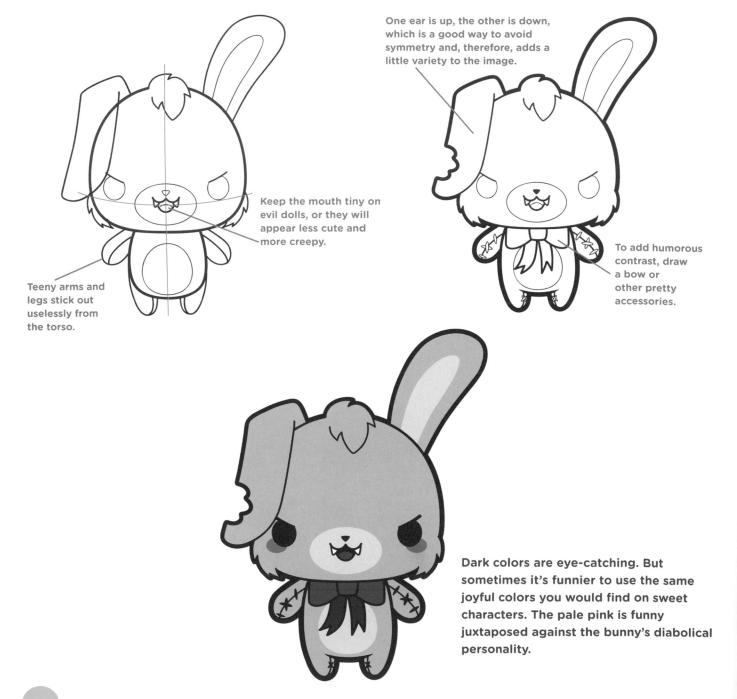

One ear is up, the other is down, which is a good way to avoid symmetry and, therefore, adds a little variety to the image.

Keep the mouth tiny on evil dolls, or they will appear less cute and more creepy.

Teeny arms and legs stick out uselessly from the torso.

To add humorous contrast, draw a bow or other pretty accessories.

Dark colors are eye-catching. But sometimes it's funnier to use the same joyful colors you would find on sweet characters. The pale pink is funny juxtaposed against the bunny's diabolical personality.

evil kitty

The head is a simple oval, with dot eyes and a split lip, which is generic for many animals. Only one thing identifies it as a cat: the triangular ears. Therefore, it's important to draw them in detail. The way to do that is to articulate the interior (the pink area). The claws and tail also help identify this evil kitty. This exercise in minimalism results in a strong design. More detail might be effective in spelling out the species, but it would also detract from the Kawaii style.

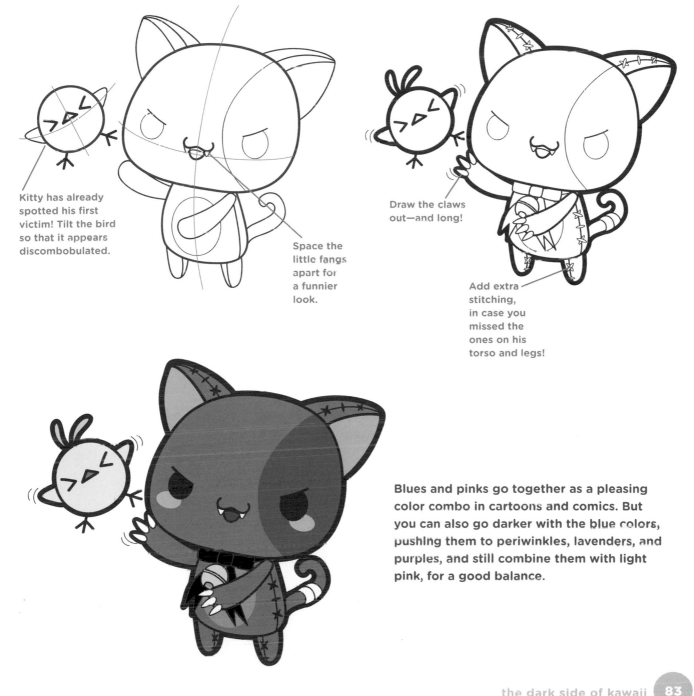

Kitty has already spotted his first victim! Tilt the bird so that it appears discombobulated.

Space the little fangs apart for a funnier look.

Draw the claws out—and long!

Add extra stitching, in case you missed the ones on his torso and legs!

Blues and pinks go together as a pleasing color combo in cartoons and comics. But you can also go darker with the blue colors, pushing them to periwinkles, lavenders, and purples, and still combine them with light pink, for a good balance.

bad girls

The most widespread and popular characters in all of dark Kawaii are its bad girls. How bad are they? They litter. They talk loudly in hospital zones. They don't signal when they switch lanes. I am talking B-A-D bad. Let's take a look at the wide variety of these hilariously cruel ladies.

biker tots

These cute, thimble-sized rebels are looking for trouble. Draw them with an intimidating look in their eye. Give them self-assured, forward-leaning postures. They often display intimidating emblems or insignia. Don't give them silly expressions; draw them as if they were actually serious characters. This will have the opposite effect and make them look even more humorously appealing.

Now, about drawing motorcycles . . . think you can't draw one? No worries! These bikes aren't only hugely simplified but all the detail is *supposed* to be omitted to keep the style consistent. Therefore, the bike is made up of only a few basic shapes, as you'll soon learn.

LEADER OF THE TOTS

Take a look at the attitude and body language on this one: Fists firmly planted on hips, she's ready to take on any trucker in a grueling thumb-wrestling fight. The skull accessories in her hair have Xs for eyes—which in cartoon language means they've been punched out. Notice her few teensy eyelashes; this barely softens her look.

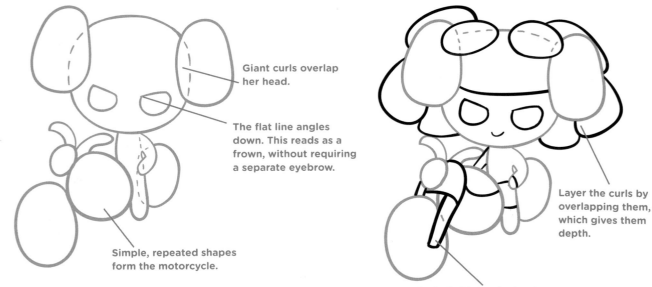

Giant curls overlap her head.

The flat line angles down. This reads as a frown, without requiring a separate eyebrow.

Simple, repeated shapes form the motorcycle.

Layer the curls by overlapping them, which gives them depth.

Forks hold the tire in place.

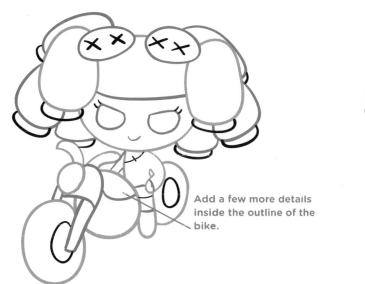

Add a few more details inside the outline of the bike.

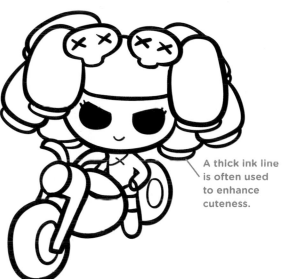

A thick ink line is often used to enhance cuteness.

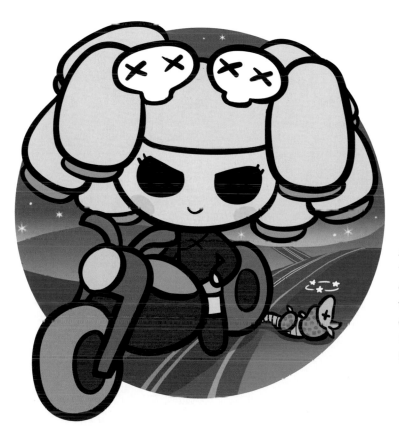

A good strategy is to make "bad" characters dark yet colorful. In addition, it makes the character pop if you add one bright color to the mix. In this example, sickly yellow hair does the trick.

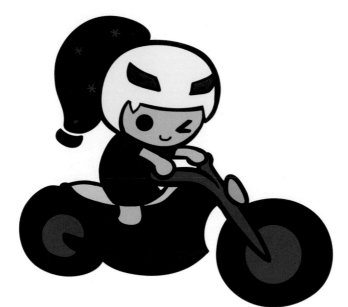

RIDING THE HOG

A Kawaii girl on a lowrider creates humor by combining two improbable elements: the biggest, baddest bike and a gumdrop-sized rider.

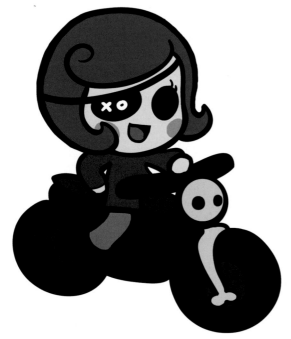

WRONG WAY WANDA

So what if she has no depth perception? Does she let a little thing like vision interfere with her cruising? No way!

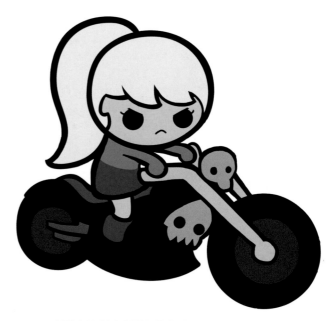

MEAN MACHINE MOLLY

Out of her way, boys. She owns this stretch of the avenue—all two inches of it!

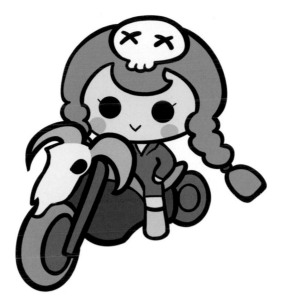

GOOD-NATURED OUTLAW
Notice the humorous contrast between the goat skull and the girl's dainty smile.

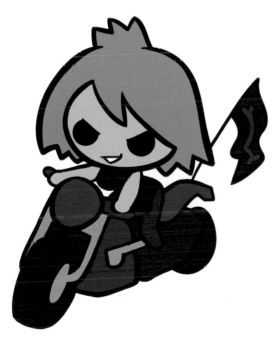

MEAN MAMMA
Atypical coloring conveys her evil personality. Note the gray skin color. More hemoglobin, please!

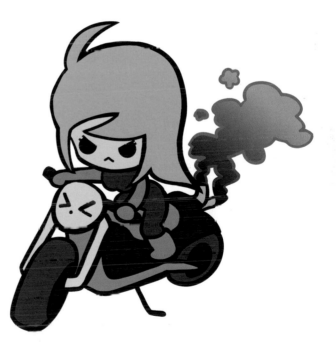

THE POLLUTION EXPRESS
There are laws against riding without a helmet—but they're seldom enforced against cartoon characters. Omitting the helmet gives the reader a better view of the character.

dark brides

Dark brides are poster girls for prenup agreements. Be that as it may, these dark characters offer a fresh and edgy mix of styles: ultragloomy and supercute. How else would you describe wedding gowns worn by cute zombies? If these were plush dolls, you couldn't keep them on the rack.

ALL DRESSED UP AND NO ONE TO MARRY

Her groom failed to show up. What a shocker! And it was going to be such a nice outdoor cemetery—oops, I meant, *ceremony*. She even brought along the family pet to witness the event: a black crow, which she holds on her arm. The character design is inherently amusing: The hair is slightly taller than her head! Layer the gown, but *keep it simple*.

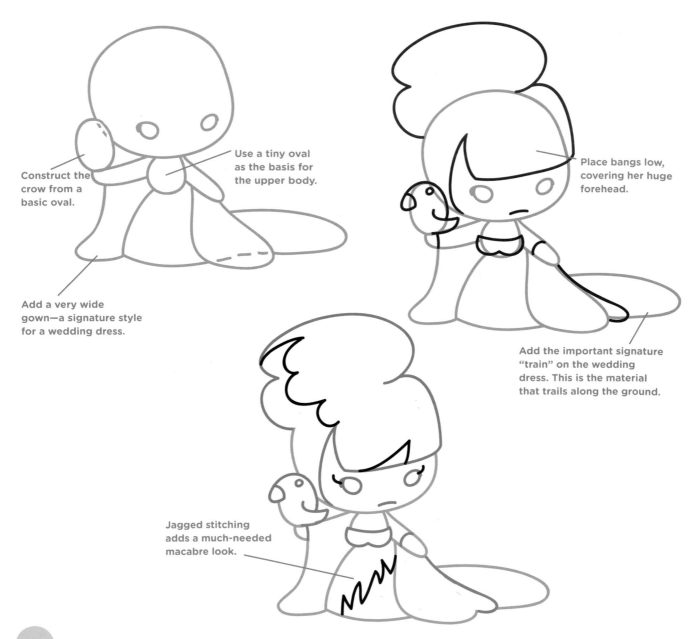

Construct the crow from a basic oval.

Use a tiny oval as the basis for the upper body.

Add a very wide gown—a signature style for a wedding dress.

Place bangs low, covering her huge forehead.

Add the important signature "train" on the wedding dress. This is the material that trails along the ground.

Jagged stitching adds a much-needed macabre look.

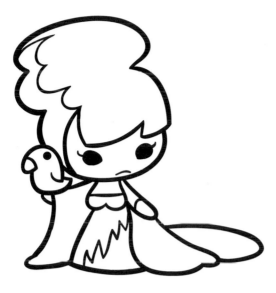

These characters wear "nighttime" colors. Keep them comically gloomy. Don't misunderstand. That doesn't mean that you should choose only dull or dreary colors. Instead, create an *entertaining* version of a dreary image, not an actual dreary image. This is a very important distinction to make.

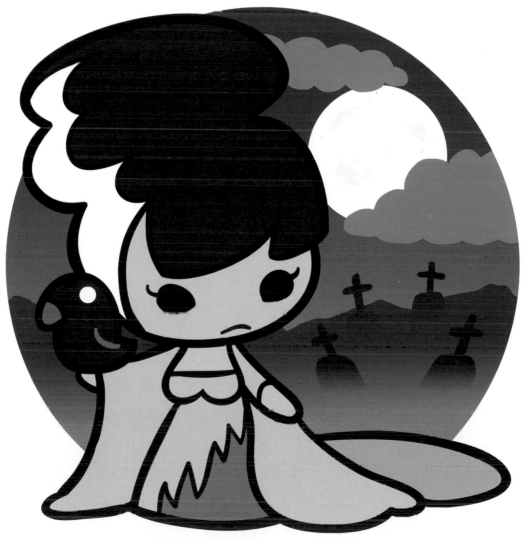

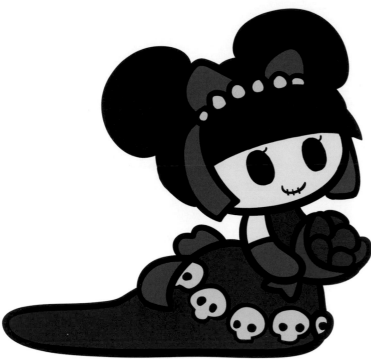

WALKING DOWN THE AISLE
Like the black roses? Funny touches like this create memorable characters. Note the small stitching holding her mouth together.

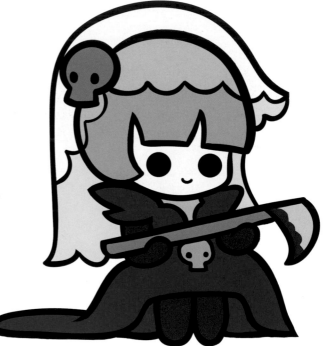

WHAT'S WRONG WITH THIS PICTURE?
Sometimes, the most effective approach in creating humor is to play it straight but then introduce, without emphasis, incongruous elements, like the bloody scythe. It's a shame how a little thing like a weapon, dripping with blood, causes some to label a character as "bad." People are so quick to judge.

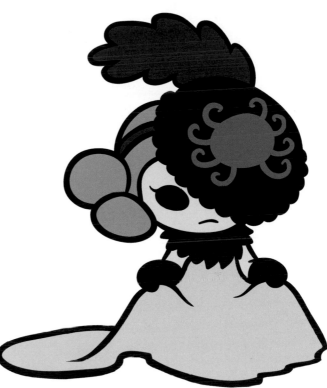

BLACK WIDOW

If she keeps bugging you to get more life insurance before the wedding date, that's a red flag! To emphasize her sinister nature, she's dressed in black and gray. That lovely spider ornament sucking on half of her face is also an indication that you two won't be living happily ever after.

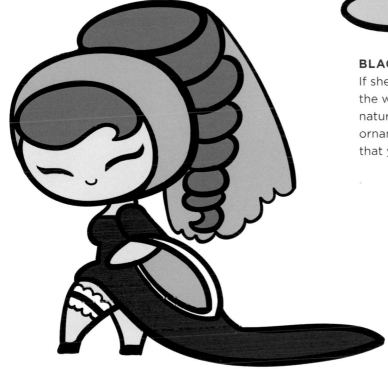

DANGEROUS BEAUTY

This character appears to have too much self-esteem. But that's what makes her funny. Note the contrasting linework—the extralong, stylish lines of the eyes and the tiny curved line of the mouth.

devilish divas

Instead of portraying the epitome of evil, as they do in every other genre of manga, devils and demons in Kawaii are commonly drawn as cherubic baddies who are loved for their mischievous nature. They're often depicted as small, hyperactive, and harmlessly flirtatious.

The hallmark visuals for a supercute devil or demon are red skin, horns, a pitchfork, a tail, and cloven hooves. But you don't have to pile all these elements onto a single character (unless it works). You just have to use enough of these iconic traits so that the viewer instantly recognizes the character type. Sometimes, only one or two elements, like horns and a pointed tail, are enough. It takes a bit of initial sketching to arrive at the right combination of elements.

FLAMING DEVIL BABY

She may be small, but she's already intent on causing trouble (if that mischievous expression is any indication). Once again, the technique of juxtaposing big shapes against smaller shapes proves effective in creating a humorous resulting image. Those humongous horns, attached to that tiny character, make this image fun right from the start.

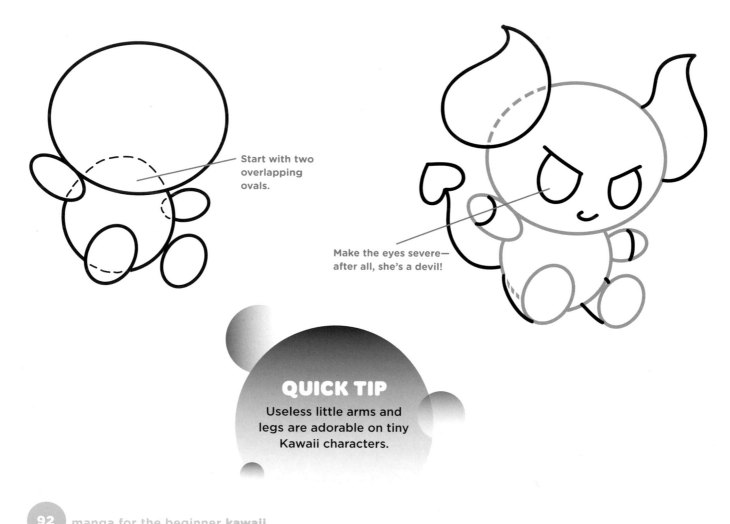

Start with two overlapping ovals.

Make the eyes severe—after all, she's a devil!

QUICK TIP
Useless little arms and legs are adorable on tiny Kawaii characters.

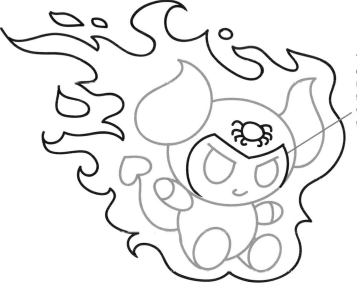

The addition of the sharply defined cutout around the face allows the character to remain simple and basic while injecting a fun element to the costume.

Yellow and red are complementary colors in comics. Placed together, the contrast heightens the effect of both colors.

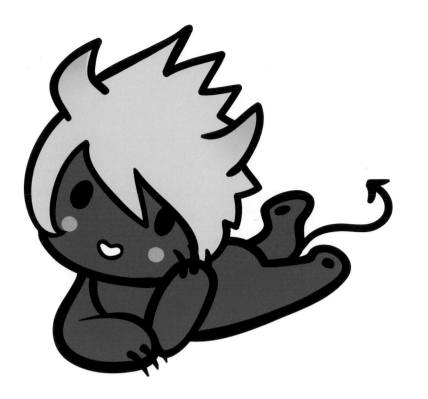

QUICK TIP

Manga artists are always looking to push the envelope and come up with fresh angles for their character designs. And one important element of that is color. You can invent some of your own edgy color combos.

DEVILISH COLORS

A cute and simplified character colored in a single, bold color gives the impression of being clothed by the pigment itself.

PRETTY IN PINK

The red-hot color theme associated with devils can be tweaked while still keeping the same general concept. Pink-magenta reminds us of the devil theme but is more feminine—like the character herself.

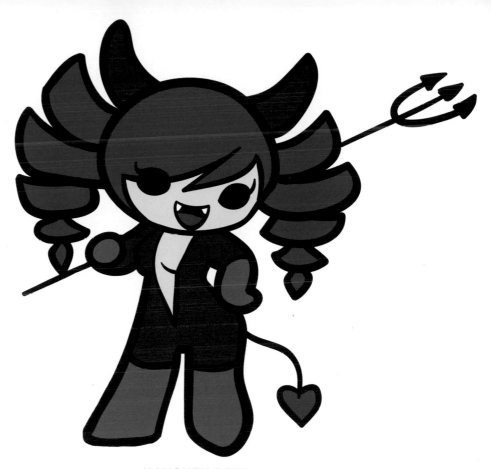

NAUGHTY DEVIL

Although they can seem bad, this is about as naughty as they get. Note how her curls are so simplified that they almost become a graphic design.

THE GOOD-GIRL DEVIL

I included this character because she's also a popular type. She's the devil with a heart of gold: nice, friendly, and well-mannered.

witches

Teen witches are experiencing a resurgence in popularity. However, Kawaii witches offer tiny, miniversions so darling that you almost welcome the idea of getting zapped and turned into a frog. Witches are particularly easy characters to draw, because they share iconic accessories that make them instantly recognizable. By using these props, you can draw any type of cutie, and she'll still come across looking like a witch.

MIDNIGHT FLIER

To make this classic pose work, the character has to be drawn leaning forward. Many beginners draw this pose with the character sitting upright, which is easier but unnatural. Draw her body in a side view, but keep her head facing front, providing a clear look at her cute expression. The legs don't dangle straight down but brush back, showing the effects of her forward momentum.

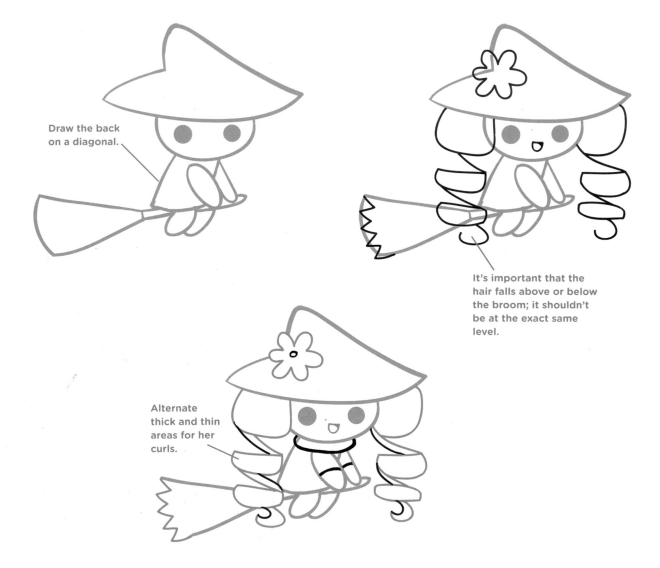

Draw the back on a diagonal.

It's important that the hair falls above or below the broom; it shouldn't be at the exact same level.

Alternate thick and thin areas for her curls.

Witches' hats aren't only tall but wide, and with a brim that extends beyond the head.

* Tall witch's hat
* Long, billowing dress
* Cape
* Black cat (as a buddy)
* Bats (as background elements)
* Cauldron
* Wand
* Broom
* Potions

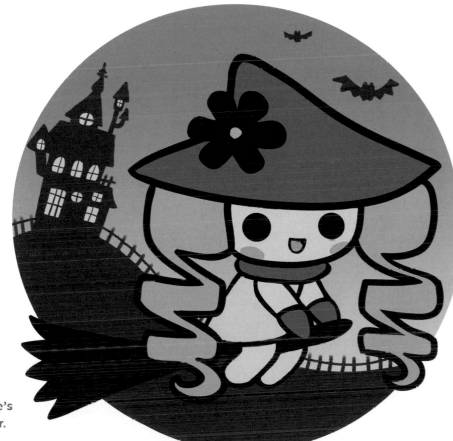

Show her taking an easy glide across the page—she's a witch, not a dive bomber.

gothic-style cat girls

If you thought the combinations of characters and styles couldn't get any weirder, think again. I mentioned earlier that Kawaii was a deceptively simple, yet creative genre, with a wide variety of original character types. This is a perfect example. Often, genres that have the least in common with each other can be combined to create the most appealing new styles, such as Goths and cat girls. People want what's fresh and different. By combining extremes, you can achieve that effect.

With the following examples, only a touch of gothic influence has been added, but it's enough to give them a unique style. Basically, they're all a bit darker than the peppy, bubbly cat girls we're used to seeing. Some also have frills, an excess use of the color black, jagged hemlines or flounces, Victorian-style clothing, or pale skin tones.

CAUGHT IN THE RAIN

If cats hate water, then cat umbrellas have to be the answer. Looks like the umbrella likes it more than she does. A gothic touch is provided by the two jagged hems on the outfit, as well as the amount of black used as part of the palette.

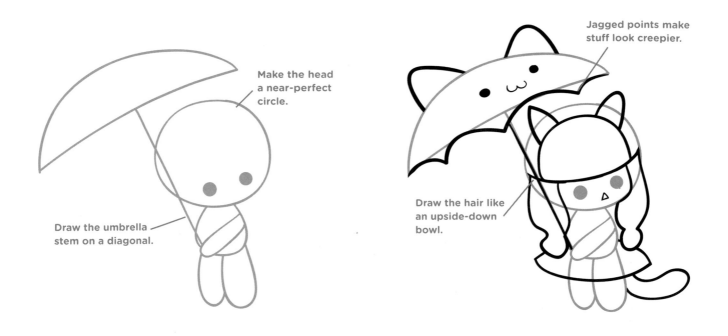

Make the head a near-perfect circle.

Draw the umbrella stem on a diagonal.

Jagged points make stuff look creepier.

Draw the hair like an upside-down bowl.

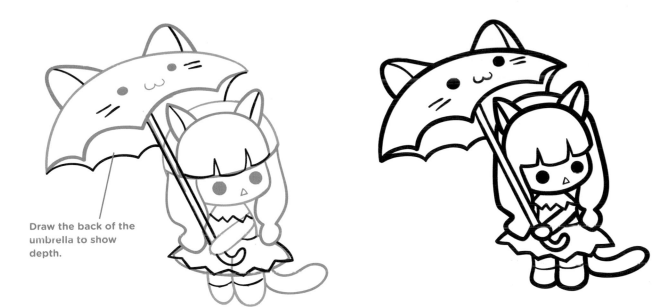

Draw the back of the
umbrella to show
depth.

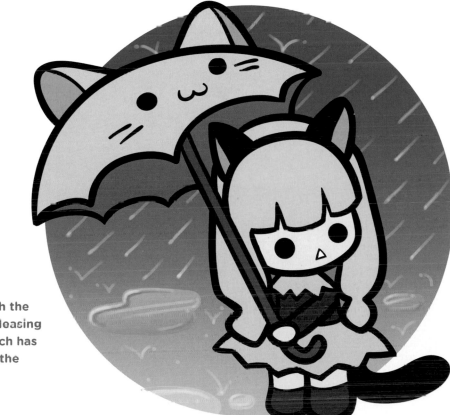

The feet break through the
circular template—a pleasing
design technique, which has
the effect of bringing the
character forward.

KITTY WITH A FISH
Is she holding a pet or lunch? You decide.

GOTHIC AND LOLITA FELINE
The frills and lace, along with the darkness
theme (skulls tend to provide that), places
this kitten firmly in the gothic and Lolita
"cat-a-gory."

KITTY EARS

Here's an interesting approach to drawing cat ears. By silhouetting them, they appear as part of the hairdo. They also flatten out the image. This is part of what makes Kawaii look so cool.

SUPERSTYLIZED CAT

This one is as much a design as she is a drawing. She's based on broad shapes, simplified linework, and flat-looking graphics. Note the pale skin, a popular feature among gothic characters.

grim reapers

If not for the examples in this section, you'd think I was nuts to say that Grim Reapers—Death personified—are some of the most adorable characters of dark Kawaii.

These tykes present the ultimate irony: archetypical, primitive, evil clothing infused with an insane, baby-doll cuteness.

reaper and buddy

Kawaii-style fantasy pets can be used as evil mascots for lots of Goth-type characters. This one here is a very cute bat (with a very cute case of rabies).

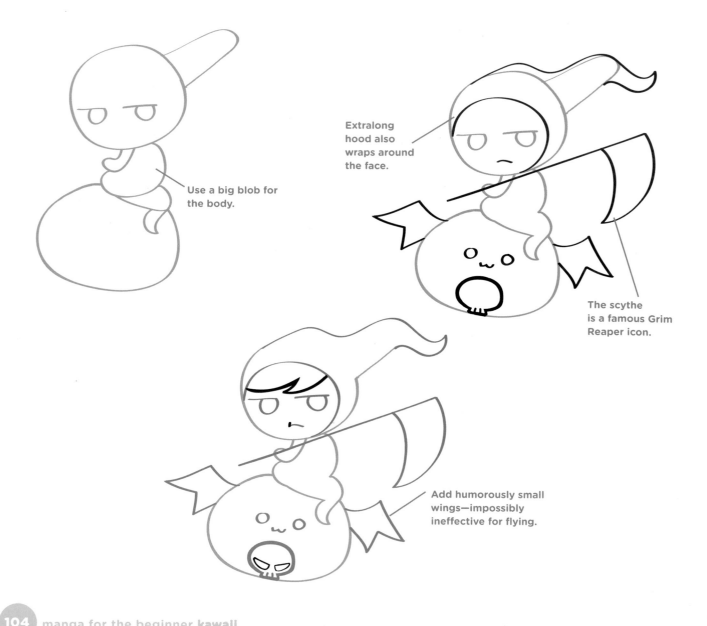

Use a big blob for the body.

Extralong hood also wraps around the face.

The scythe is a famous Grim Reaper icon.

Add humorously small wings—impossibly ineffective for flying.

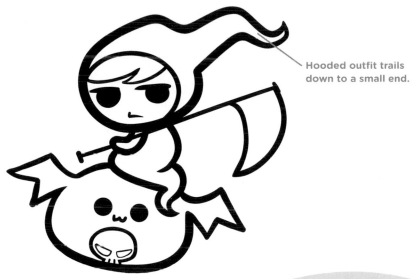

Hooded outfit trails
down to a small end.

Make the background creatures
(ghosts) even simpler than the
Grim Reaper; otherwise, they'll
distract from the main character.

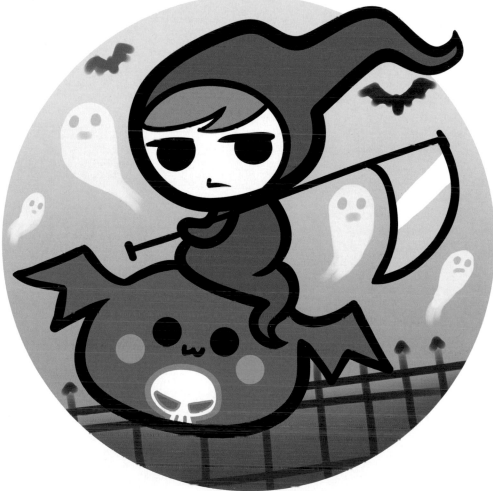

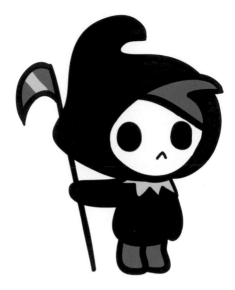

LITTLE LOST REAPER

He looks lost. Don't worry, Little Reaper, there's got to be a cemetery around here somewhere.

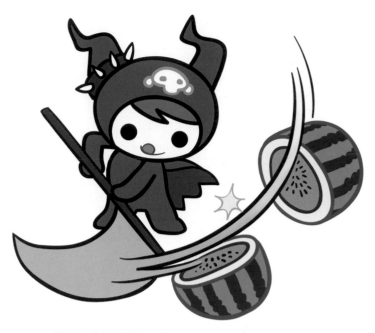

GRIM REAPER AEROBICS

Don't try this at home. The more innocent and earnest you make your cute-looking Grim Reaper, the more appealing—and memorable—he'll be.

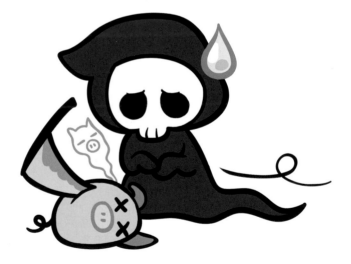

WHOOPS!

Didn't Grim Reaper's mom ever warn him not to play with sharp objects? Poor Reaper. He feels so bad about accidentally puncturing his piggy pal. Buck up, little friend. You'll feel better once you get back to work. And kill someone else.

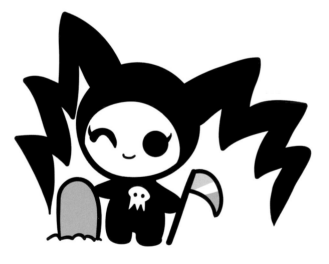

HUGGABLE REAPER

All she wants is a hug. But since anyone the reaper touches instantly passes away, maybe you ought to friend her on Facebook instead.

skeletons

When coming up with an array of dark Kawaii supercuties, don't forget a significant group of characters, which are, improbable as it may sound, so popular that they've practically become a staple in the genre. I'm talking about skeleton-based characters.

"What?" you say. "Why, I can't believe it! Can this possibly be true?"

Yes, my stunned friend, it's not only possible, but it's a fact. These toddleresque Goths are weirdly charming and never truly nightmarish.

To evoke sentimental feelings on the part of the reader, the skeleton's adorable proportions must override its typical, ghoulish nature. By basing your skeleton characters on the proportions of babies, you trigger a subconscious sympathetic emotion. These skeleton characters are as cute as infants and never need changing.

Skeleton heads are always supersimplified. Often, the head is based on nothing more than the top half of the skull, leaving off the bottom half completely. The skulls are always rounded and only vaguely representational of a real skull.

skeleton pirate

Like knights and swords, or Vikings and horn hats, pirates and skull motifs go together. See the emblem on the pirate's hat? Repeating the skull motif not only ties together the disparate elements of the costume but also drives home the identity of the character. Note, too, the classic, long coat that pirates wear everywhere—into battle, at feasts, and when they sleep. Is this a versatile coat or what?

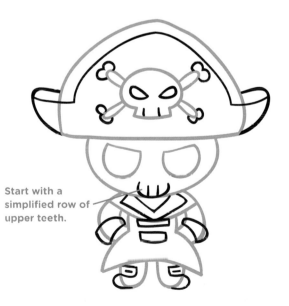

Start with a simplified row of upper teeth.

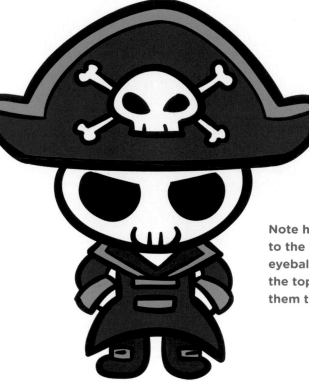

Note how the eyebrows give expression to the eyes, even though there are no eyeballs. The eyebrows press down on the top of the empty eye sockets, causing them to angle downward into a scowl.

TECHNIQUES FOR GIVING A SKULL PERSONALITY

* Use cute but small expressions (work the eyebrows; leave the eyes hollow).
* Add hair. (Oh yes, some of these suggestions are weird, but they work.)
* Use hoods, hats, or scarves. You don't want your skull to catch cold.
* Make the skull part of an emblem on a hat or a hood, which the character is wearing, rather than the actual head of the character.
* Add animal ears.
* Tilt the head, and make the body language express cute attitudes.
* Make eye patches, scars, bandages, and other small, unobtrusive accessories look cartoonish.

skeleton cowboy

While it's true that you don't see cute skeletons roaming the Old West, you do see them in Kawaii; however, if you *have* seen them in the Old West (or anywhere else besides this book), it's time to check back with the clinic!

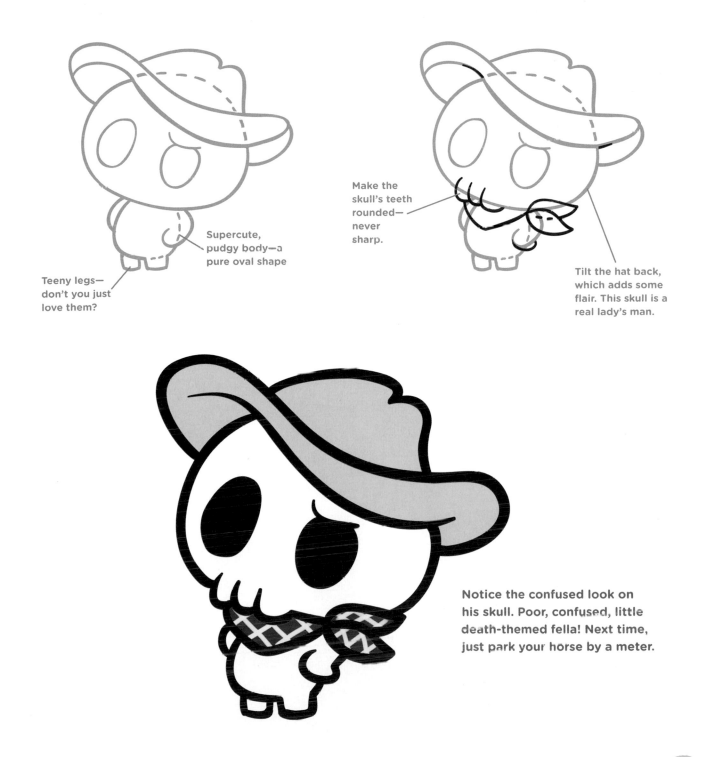

Supercute, pudgy body—a pure oval shape

Teeny legs—don't you just love them?

Make the skull's teeth rounded—never sharp.

Tilt the hat back, which adds some flair. This skull is a real lady's man.

Notice the confused look on his skull. Poor, confused, little death-themed fella! Next time, just park your horse by a meter.

skeleton island girl

In Kawaii, there exists a total lack of rationality for how choices are made to combine costumes with character types. Why would a miniature girl character, with an oversized skull for a head, be dressed in a tropical outfit? It's so odd it tickles the imagination.

Why does the technique of randomness work in Kawaii? Who knows? Who cares? It works.

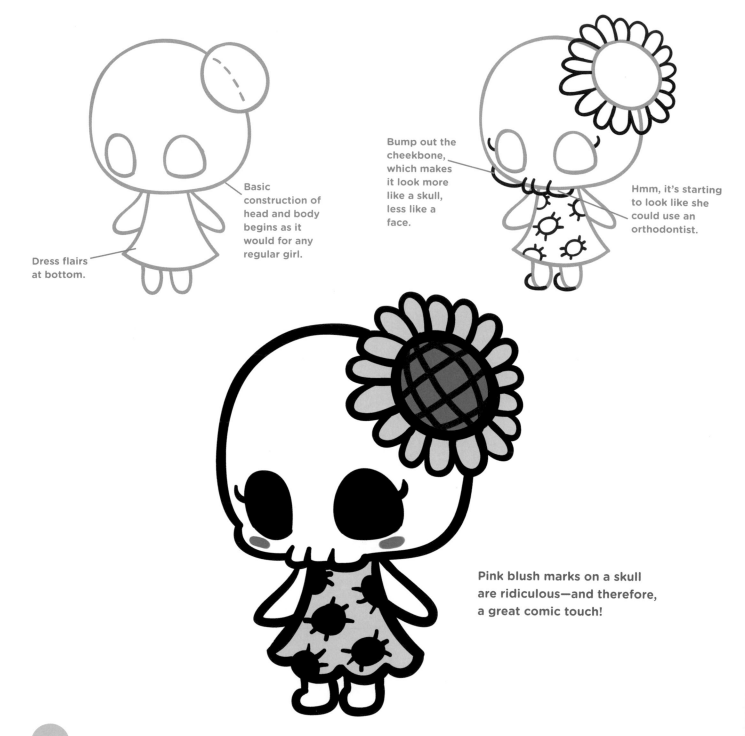

Basic construction of head and body begins as it would for any regular girl.

Dress flairs at bottom.

Bump out the cheekbone, which makes it look more like a skull, less like a face.

Hmm, it's starting to look like she could use an orthodontist.

Pink blush marks on a skull are ridiculous—and therefore, a great comic touch!

skeleton critters

This fun subset of skeleton Kawaii combines supercuddly critters with ghoulish skulls to create macabre-looking mischief-makers. With these characters, you have to resist the urge to add detail to define the character, and find a way to do it by using fewer lines.

skeleton bunny

Why does this spooky bunny look so cute? If you can answer that, you'll understand an important secret about character design. I mean, it's a skull, for goodness' sake! But on closer inspection, we notice that skull is based on a round circle. Circles and ovals are the essential building blocks of cute character types. Foundation shapes strongly influence positive emotions.

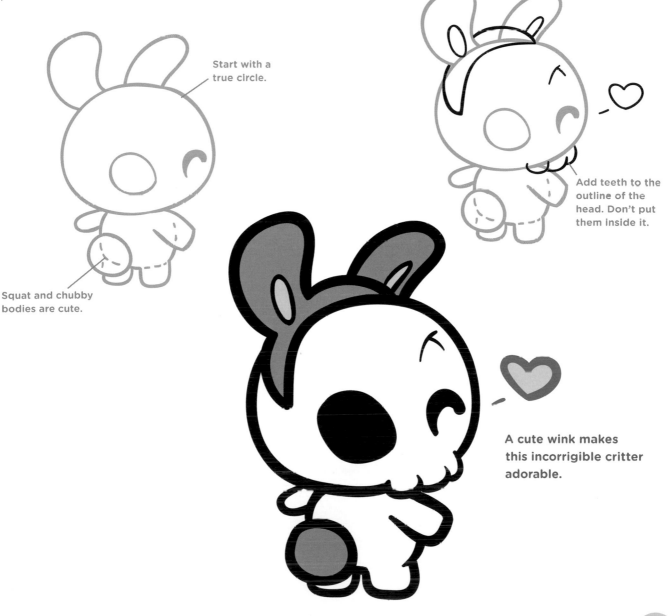

Start with a true circle.

Add teeth to the outline of the head. Don't put them inside it.

Squat and chubby bodies are cute.

A cute wink makes this incorrigible critter adorable.

skeleton puppy

Skeleton puppies make great pets for other Goths. The skull of this skeleton puppy shows a bit of flexibility—the cheeks are rounded and the teeth almost form a smile. Stylized skulls shouldn't appear stiff or brittle.

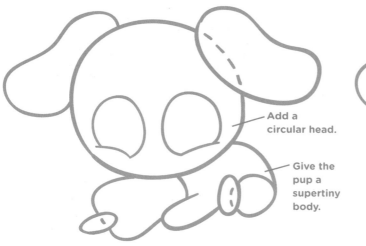

Add a circular head.

Give the pup a supertiny body.

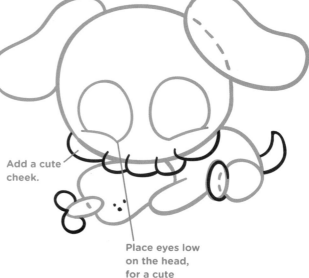

Add a cute cheek.

Place eyes low on the head, for a cute look.

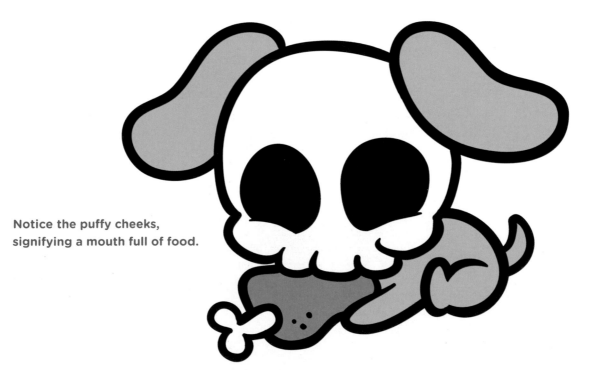

Notice the puffy cheeks, signifying a mouth full of food.

skeleton lion

This is an example of high-concept character design. The mane becomes a starburst, and the head becomes the focal center of the design. The coloring of the mane and body uses realistic lion hues, and that's essential. The coloring helps identify this wild creature as a lion.

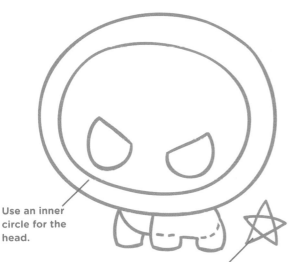

Use an inner circle for the head.

Shapes, symbols, and emblems are used to add graphics to empty spaces and to create unique attributes for characters.

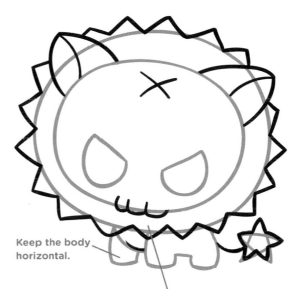

Keep the body horizontal.

Add a starburst for a mane. (Note that the jagged points of the mane are all drawn along a circle; they're not uneven.)

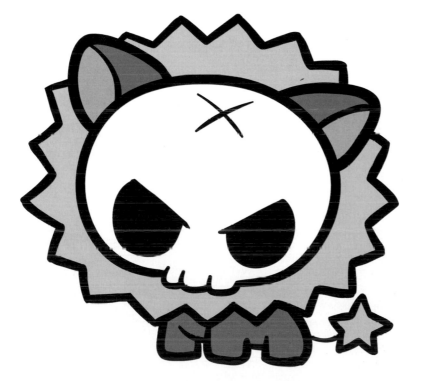

By using iconic visual characteristics of the lion, such as the mane, this creature becomes easily identifiable.

irresistible animals

Kawaii animals come in many different shapes. But you can't simply draw a small, cute version of an animal and expect it to look "kawaii." Instead, you must apply the Kawaii style to each one so that they all look like they're drawn in the same excruciatingly appealing style.

Can it be done? Of course it can be done! But it requires resourcefulness, inventiveness, and imagination to create highly stylized animal images, while still making them as easy to recognize as the original species they're based on.

The good news is that you can forget about learning animal anatomy. It would only complicate the image. (Please: No celebrating in the middle of an explanation.) Kawaii animals are stylish in their simplicity. The techniques demonstrated in this section will give you all you need to create winning animal characters.

baby deer

It's funny how certain shapes trigger an immediate reaction. And it's important, as an artist, to recognize this so that you can use those shapes to manipulate your viewers' emotions. For example, an oversized round (or oval) head often triggers a sympathetic response from a viewer.

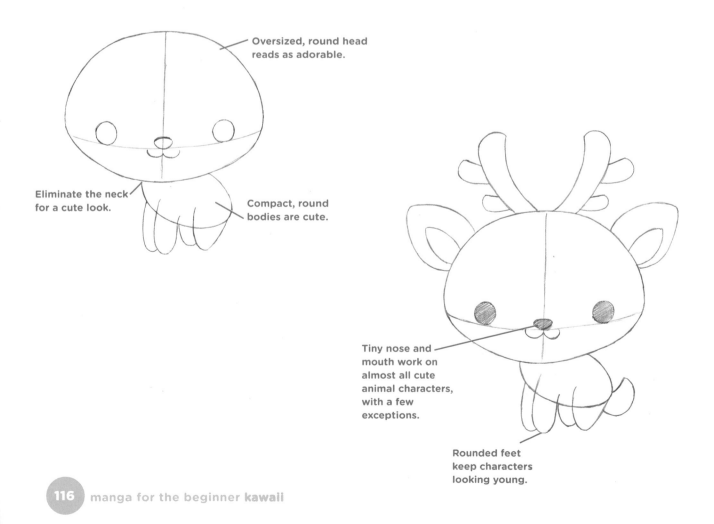

Oversized, round head reads as adorable.

Eliminate the neck for a cute look.

Compact, round bodies are cute.

Tiny nose and mouth work on almost all cute animal characters, with a few exceptions.

Rounded feet keep characters looking young.

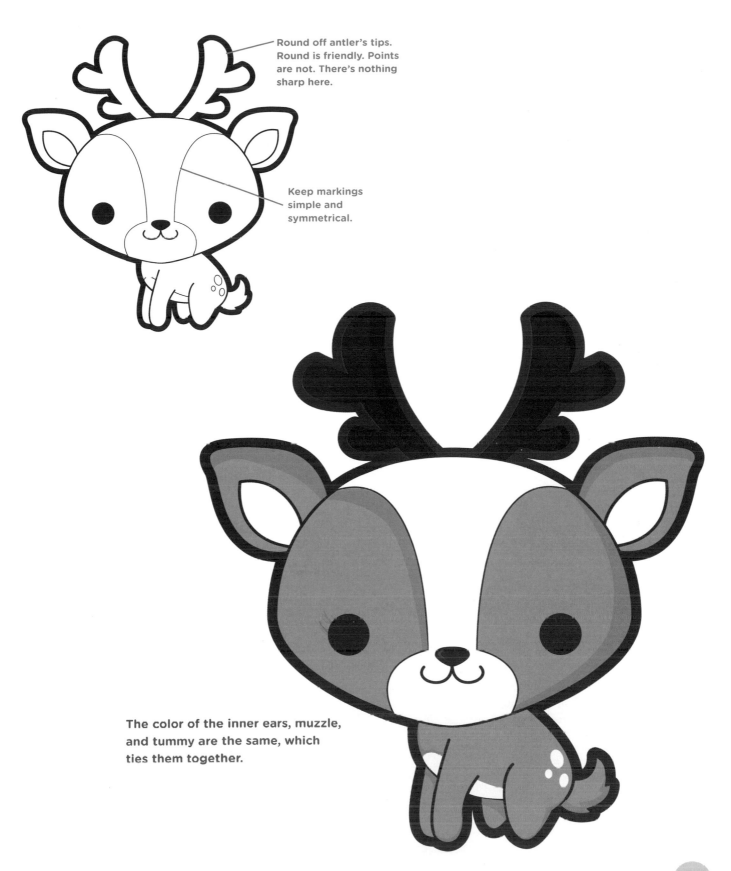

Round off antler's tips. Round is friendly. Points are not. There's nothing sharp here.

Keep markings simple and symmetrical.

The color of the inner ears, muzzle, and tummy are the same, which ties them together.

giggling penguin

We often think of penguins as cute and roly-poly. This little guy is practically a blue-and-white beach ball with a beak! Generally speaking, the rounder something is, the cuter it is. By pushing the envelope, this character design results in a penguin based entirely on a circle! Is he all head or all body or both? Science may never know the answer.

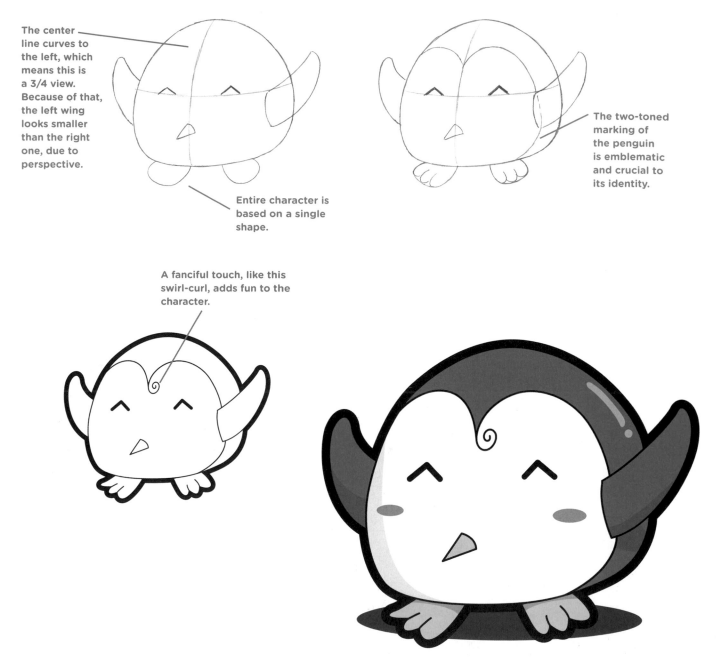

The center line curves to the left, which means this is a 3/4 view. Because of that, the left wing looks smaller than the right one, due to perspective.

Entire character is based on a single shape.

The two-toned marking of the penguin is emblematic and crucial to its identity.

A fanciful touch, like this swirl-curl, adds fun to the character.

Yes, real penguins only come in black and white. But by substituting a color for black, you liven up the image.

a jellyfish who needs a hug

Sometimes, the simplest designs are the most appealing. And this one certainly ranks up there. But how kooky is this? Who has ever heard of a cute jellyfish? Kawaii fans are no strangers to weirdness and charm, all rolled into one precious package. Look at those big, brown eyes and sweet, fluttering eyelashes. You're almost tempted to give her a hug. Mmm . . . maybe not.

This character is funny, because it's created using a technique that works to evoke visual humor—*high contrast*. The large upper body is placed on top of teensy little legs. I mean, how can that not be funny?

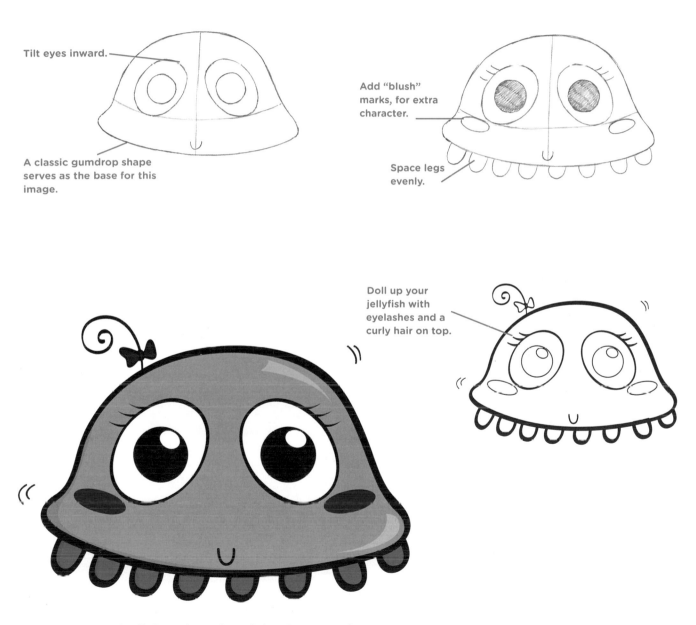

Tilt eyes inward.

A classic gumdrop shape serves as the base for this image.

Add "blush" marks, for extra character.

Space legs evenly.

Doll up your jellyfish with eyelashes and a curly hair on top.

The lighter the color of the character, the darker the eyes have to be.

fantasy creatures

Animals are also used as the foundation and inspiration for creating Kawaii fantasy creatures. Fan-favorite characters like these are delightfully whimsical. Often, only the slimmest remnants of the original animal remain in the final, evolved version. But that's fine. You're just using it to kick-start your imagination. Flying animals work particularly well as fantasy creatures. In fact, they don't even have to look like they can fly: Teeny wings on a fat body are always funny.

hummingbird creature

This odd but funny ball of chubbiness borrows two characteristics from the hummingbird: the long beak and the upright flying posture. Why is this fantasy creature so funny-looking? The answer, once again, lies in the important concept of contrast. The bird's humongous body—a funny concept in and of itself—looks even funnier with the pair of delicate wings. (How are those things keeping him aloft anyway?)

Big, round eyes are charming but wacky alternatives, like the goggles, are a lot of fun, too. Note the funny shape—not a circle or an oval, but certainly squeezable.

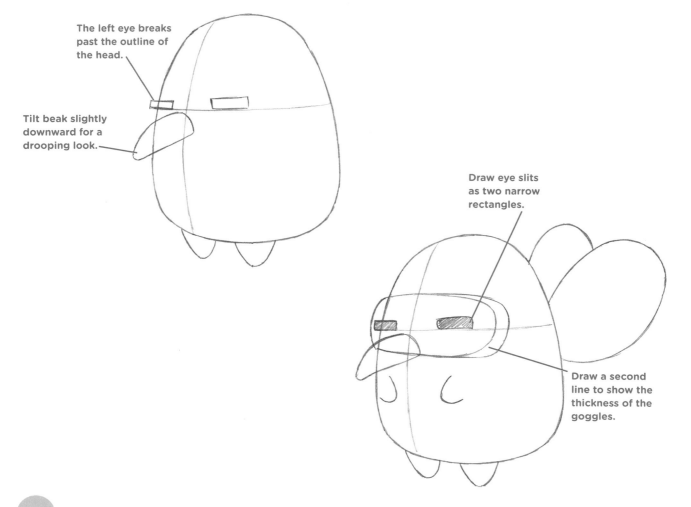

The left eye breaks past the outline of the head.

Tilt beak slightly downward for a drooping look.

Draw eye slits as two narrow rectangles.

Draw a second line to show the thickness of the goggles.

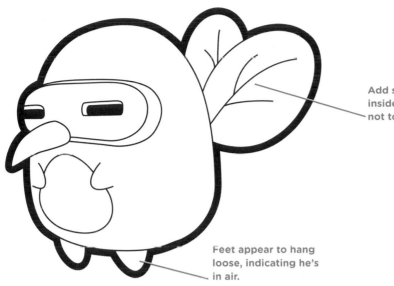

Add some veins inside the wings—but not too many.

Feet appear to hang loose, indicating he's in air.

This is a unique twist on the standard color combination of green and orange. The colors have been shifted in hue, so they aren't pure green or orange, but they still work well in combination.

cute monster

Take a gumdrop shape, stretch it, add a pair of cute rounded horns, and give it the Cyclops eye treatment (one eye in the center of the head). Now add bat wings, and color the entire thing slime green. What have you got? Beats the heck out of me! But everyone wants a little fantasy pet just like him. These little guys are the "cute monsters" of Kawaii. Pretty scary, huh? Boo! The overall simple shapes, funny and harmless monster motifs, and friendly expression make this little guy irresistible.

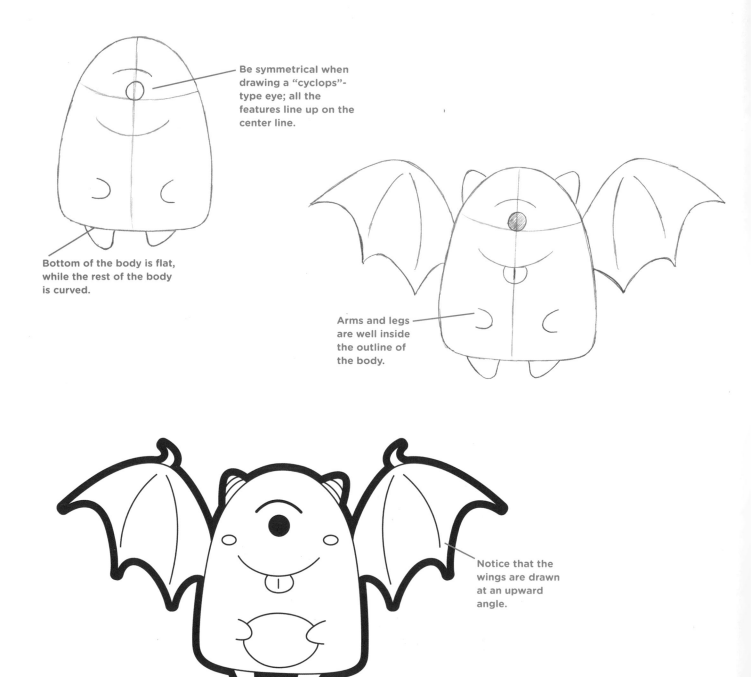

Be symmetrical when drawing a "cyclops"-type eye; all the features line up on the center line.

Bottom of the body is flat, while the rest of the body is curved.

Arms and legs are well inside the outline of the body.

Notice that the wings are drawn at an upward angle.

CREATE YOUR OWN MONSTER

You can copy this cute monster just as it appears below, or you can draw it with your own, personal twist on the material. In other words, using your imagination, you can make enough changes to the original creature that it becomes a unique character all your own. Here is a list of elements you can add and change to create a unique monster:

* Give it two eyes instead of one.
* Make the wings feathered.
* Turn the horns into long, pointed ears.
* Make the mouth a tiny smile instead of a wide grin.
* Give it four tiny legs instead of two.
* Place extra spots in the color design.
* Remove the horns, and add shaggy hair instead.
* Give it a funny nose, such as a trunk.
* Change the body shape.

The horns and wings have been colored gray, so as not to compete with the colorful green head and body.

butterfly droplet

You can borrow elements, such as butterfly wings, from animals while also using simple, abstract forms for the body, such as a raindrop, a pillow, or an egg. In all these creatures, you'll notice that the arms and legs are minisized. With small limbs like that, these creatures wouldn't be much good at performing heroic or dramatic deeds. But that's not what these Kawaii critters are intended for. Their purpose is to spread happy emotions wherever they appear, whether in a graphic novel; as part of your favorite anime show; or as a mascot on sketchbooks, T-shirts, or tote bags. I wouldn't recommend drawing them with long arms and legs; that would make them look like invading aliens from outer space.

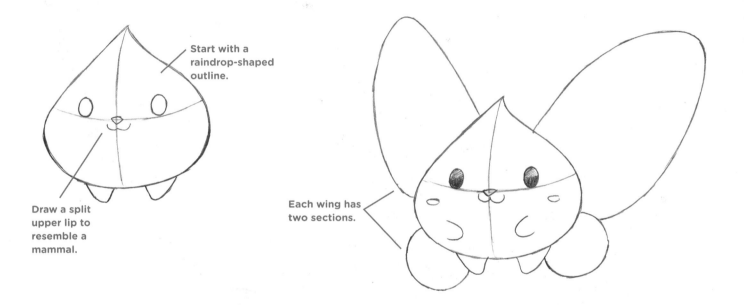

Start with a raindrop-shaped outline.

Draw a split upper lip to resemble a mammal.

Each wing has two sections.

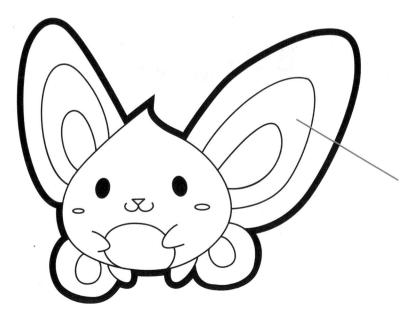

It looks better with a few interior patterns, but keep them basic.

Lots of bold colors give this character an imaginative appearance. The little pink nose in the center livens up the large purple area of the face.

sugary snacks

If you've never been formally introduced to smiling food before, then this may be a first for you. In this chapter, you'll meet some popular, Kawaii-based food groups and then learn how to draw them in humorous scenes with Kawaii-style chibis. Inanimate objects like these are often used to set the tone of a scene. They act as a relentlessly cheerful backdrop, in lieu of a more formal background, which would require a conventional horizon line, a foreground, perspective, and shadow.

CUPCAKE
Even a cupcake can blush! Keep all features small so that they remain cute.

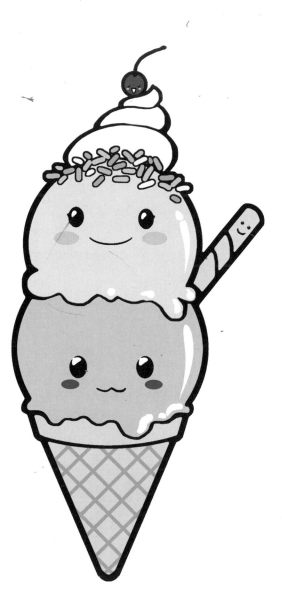

ICE CREAM CONE
Multiple scoops are always better than one. Each one needs a face. They can be smiling or arguing with each other.

DOUGHNUT

There's no such thing as an ordinary glazed doughnut in Kawaii. Kawaii doughnuts always have colorful frosting and sprinkles.

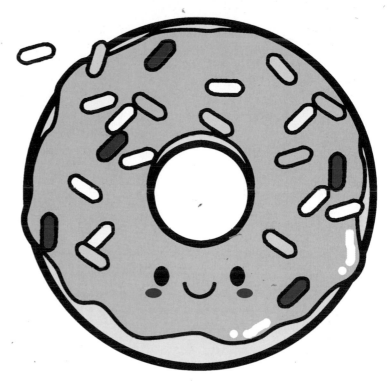

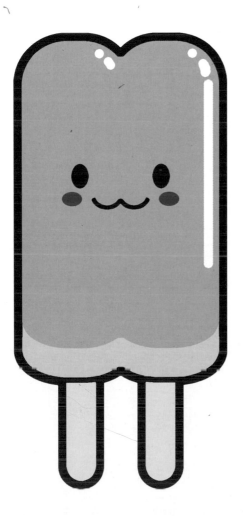

POPSICLE

Add some shines to the edge, to make it look extra happy.

eating ice cream

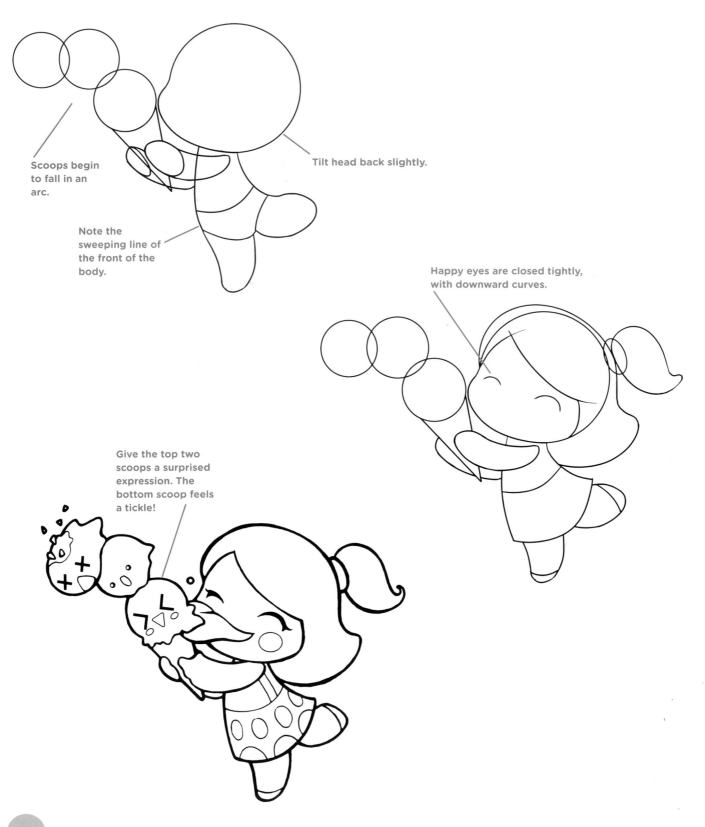

Scoops begin to fall in an arc.

Tilt head back slightly.

Note the sweeping line of the front of the body.

Happy eyes are closed tightly, with downward curves.

Give the top two scoops a surprised expression. The bottom scoop feels a tickle!

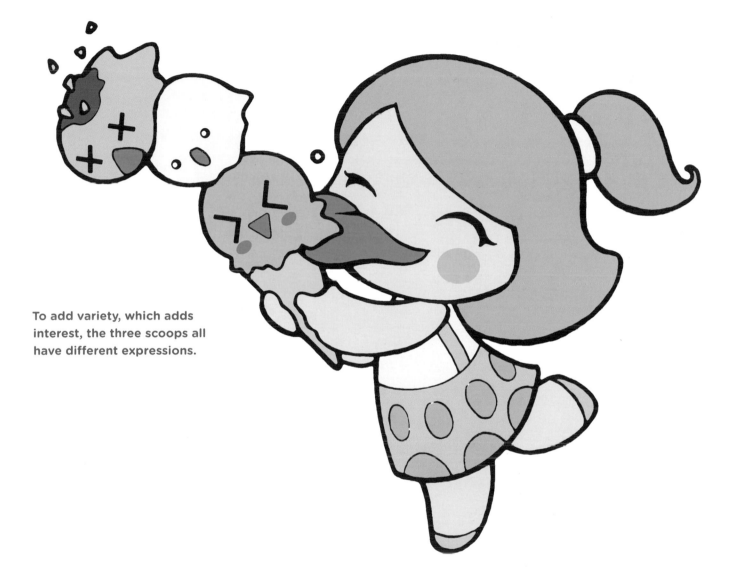

To add variety, which adds interest, the three scoops all have different expressions.

more junk food

It would be wrong to glorify these very popular but unhealthy junk food characters in this book. But that never stopped me before! Enjoy a soda while you read this section.

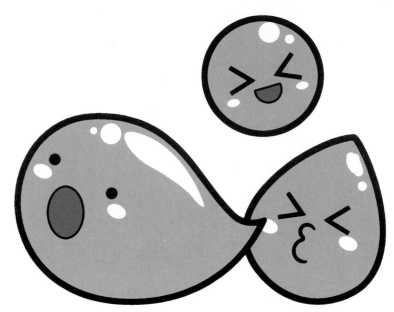

BUBBLE GUM
Bubble gum is drawn as pink blobs with shines.

CANDY CORN
The horizontal lines across the candy corn are curved, not straight.

LOLLIPOP

The inside has a swirling line—
a spiral—rather than concentric circles.

PIECE OF CAKE

By making the layers uneven, you leave
enough room in the top layer for the face
to appear.

eating pizza

Ouch! This one looks like it hurts! But the pizza is still smiling. Nothing dampens the spirits in Kawaiiland.

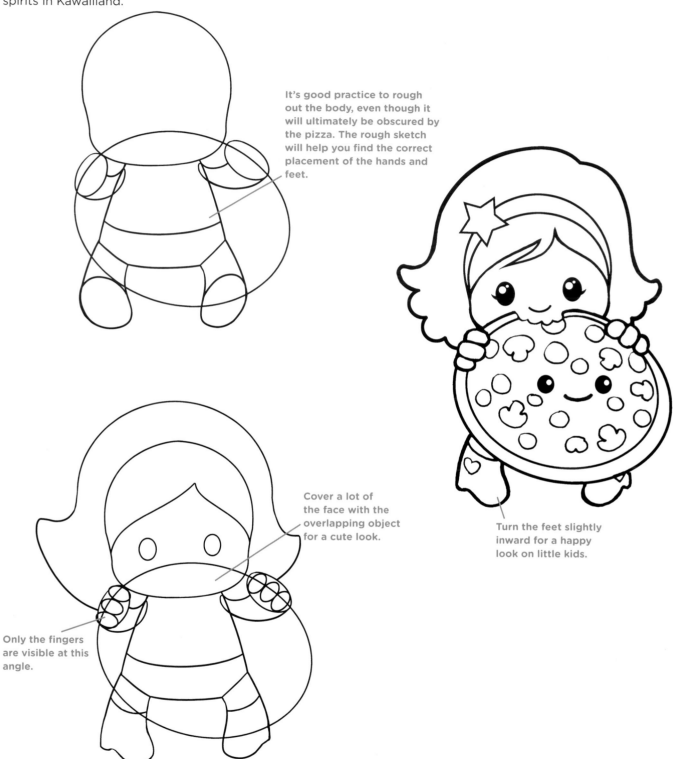

It's good practice to rough out the body, even though it will ultimately be obscured by the pizza. The rough sketch will help you find the correct placement of the hands and feet.

Cover a lot of the face with the overlapping object for a cute look.

Turn the feet slightly inward for a happy look on little kids.

Only the fingers are visible at this angle.

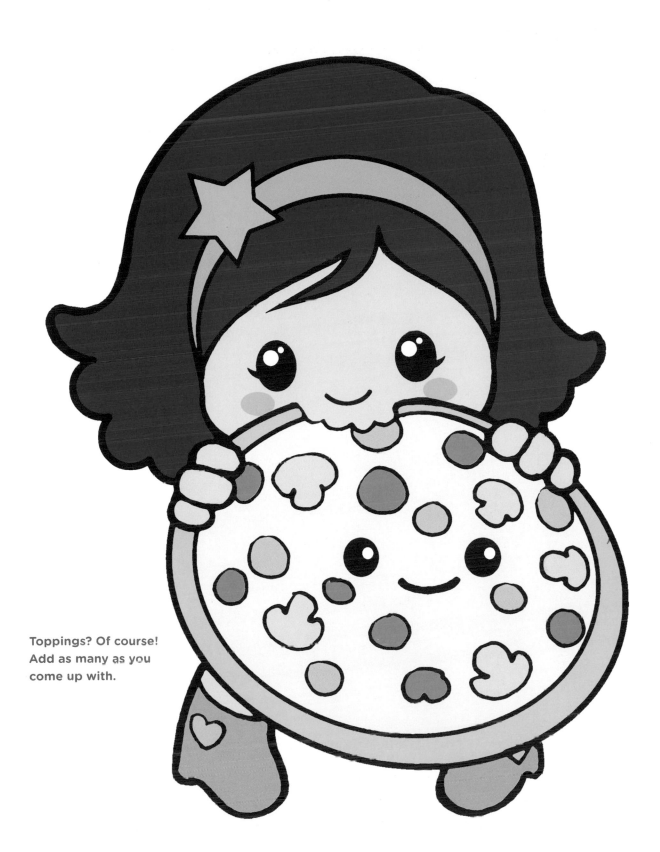

Toppings? Of course!
Add as many as you
come up with.

happy fruit

Okay, this is a little weird, but for the characters here, I want you to pretend you're drawing baby fruit—that's right, *baby fruit*—fruit so young and innocent that it gets scared if it's away from its mama for too long. It's better if you don't analyze why this approach works. There is no logic to it. We're in the land of Kawaii now. Turn off your rational mind. I will tell you when to turn it back on again, if I remember. All you need to remember is that preschooler fruit is adorable fruit.

STRAWBERRY
It's shaped like a guitar pick. Round it off at the top, or it will look like a heart with lettuce on it.

PINEAPPLE
Draw the features in the middle of the oval head shape. The green top doubles as a quasi hairpiece.

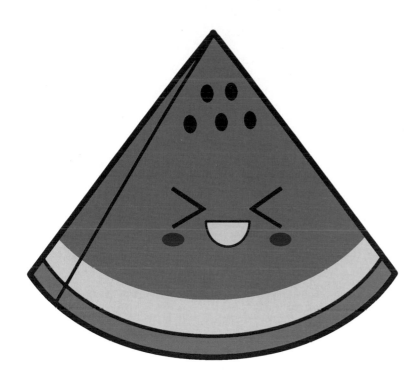

WATERMELON SLICE
The seeds are gathered near the top like a
head of hair.

BUNCH OF CHERRIES
Each cherry has a unique expression.

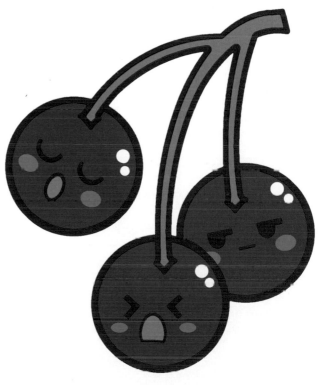

eating fruit

In this image, you'll notice that the watermelon's eyes have shines. The reason? So that they are distinguishable from the other seeds.

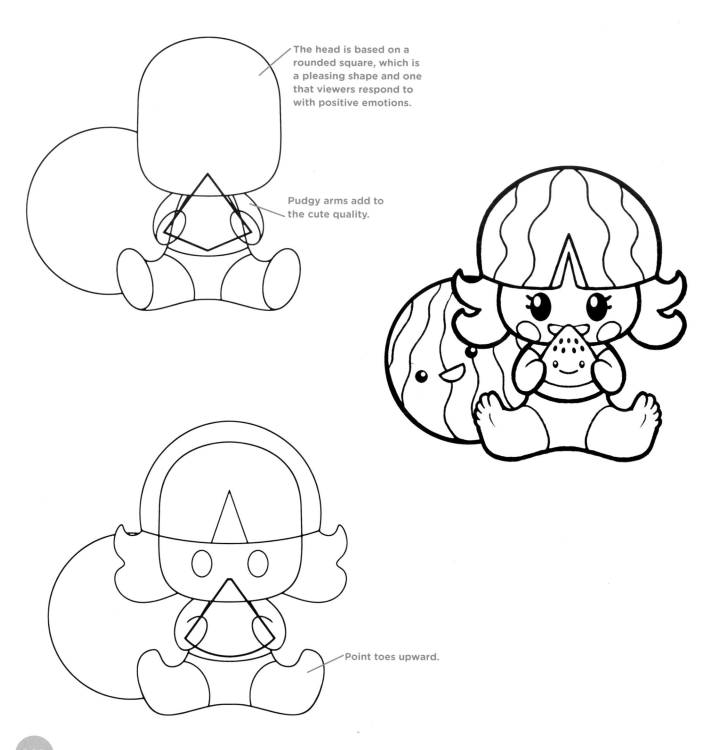

The head is based on a rounded square, which is a pleasing shape and one that viewers respond to with positive emotions.

Pudgy arms add to the cute quality.

Point toes upward.

QUICK TIP
Here's a subtle technique that's effective for emphasizing the variety of character sizes in an image: Make each character's eyes a different size, relative to the size of its overall body.

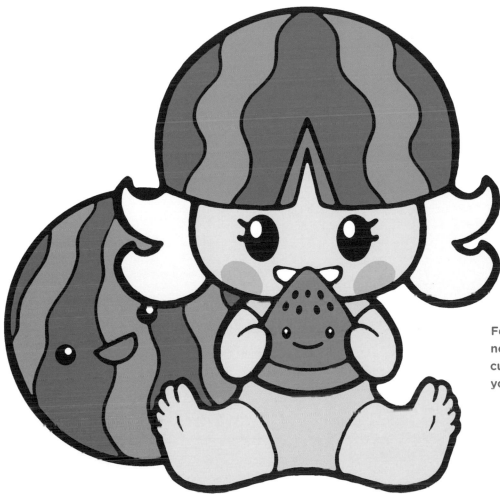

Food characters get noticed. After all, how many curious watermelons have you seen before?

japanese food

And if you're still hungry after all the treats we've just covered, there's still more.

The little foodies here make appealing characters that have practical application in advertising fast food in Japan. And just like the candies and fruit characters, the little guys in this food group are also looking forward to meeting some new human buddies and being gobbled up.

Each character features a different style of linework. For example, the take-out box is based on a solid geometric shape with ruler-straight lines. The soup bowl is a semicircle containing a variety of different shapes, including squiggly lines for the noodles. The sushi-and-rice image is made up of intricate little bumps that will drive you crazy to draw but will look great once you complete it. And the smooth egg-shaped object is a dumpling.

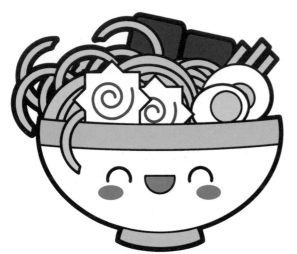

UDON
Japanese soup with noodles and all sorts of things in it. (No, it doesn't contain a prize.)

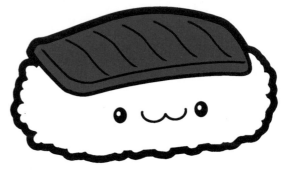

SUSHI
Sushi pieces with faces added are quite popular. Note the tuna "hat."

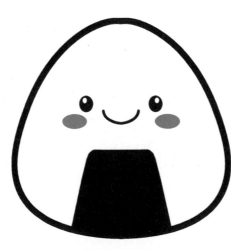

DUMPLING
Gives new meaning to the phrase *cute as a dumpling*.

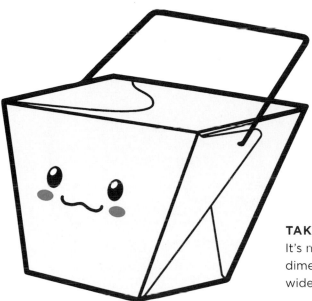

TAKE-OUT BOX
It's not just a regular box. The dimensions are different: It's wider on top than on bottom.

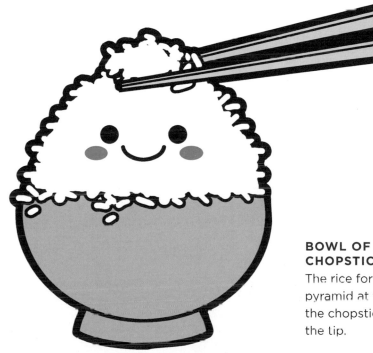

BOWL OF RICE WITH CHOPSTICKS
The rice forms a rounded pyramid at the top. Note that the chopsticks taper down at the lip.

eating sushi

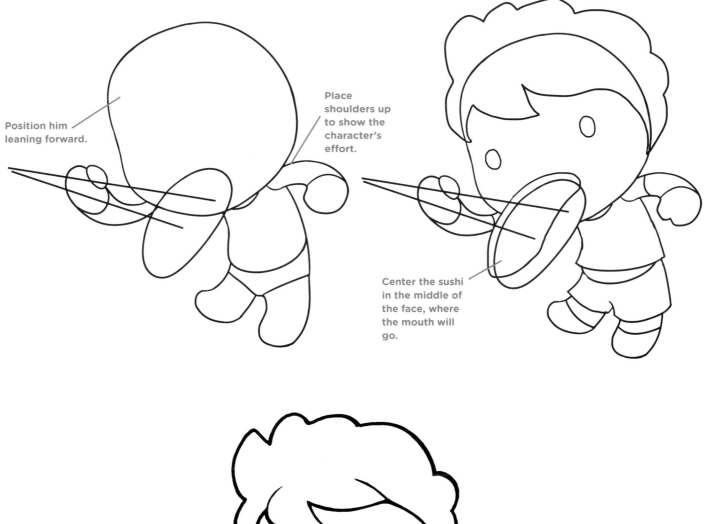

Position him leaning forward.

Place shoulders up to show the character's effort.

Center the sushi in the middle of the face, where the mouth will go.

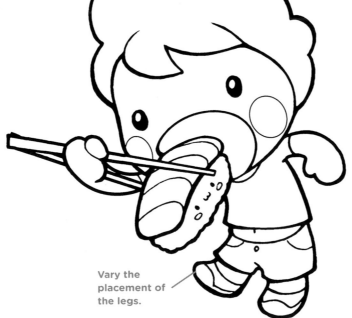

Vary the placement of the legs.

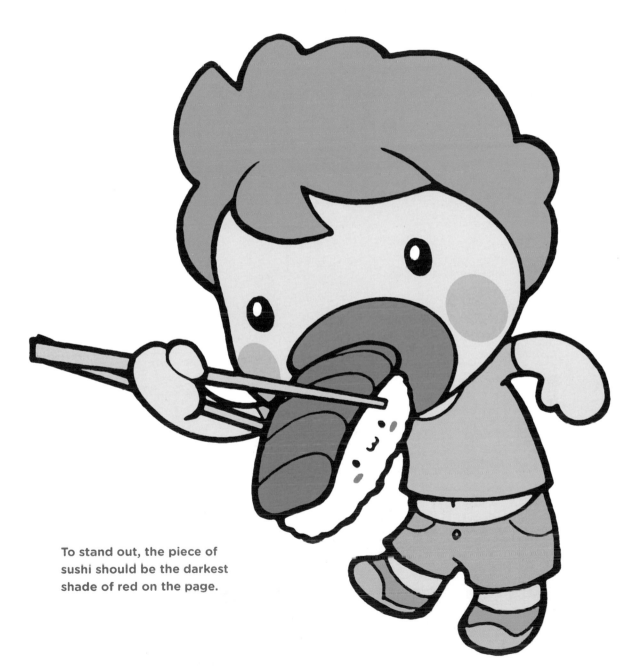

To stand out, the piece of sushi should be the darkest shade of red on the page.

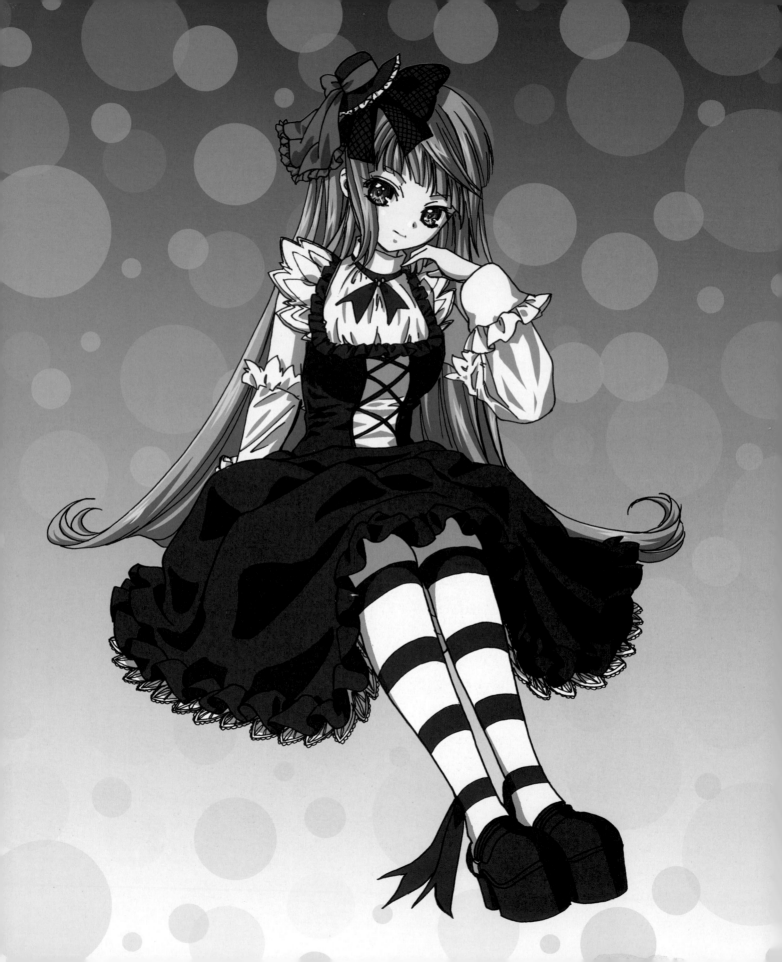

moe style

When you say that you love Kawaii to a Japanese manga artist, the response is likely to be, "Which type of Kawaii? The cute, little characters or moe (pronounced MOE-aye)?" That's because both styles belong to Kawaii and are referred to with the same umbrella term. Both emphasize charming, cute, sweet characters, but they approach them from two totally different angles. So far in this book, we've been looking at your basic cute Kawaii characters. Moe characters have been featured in popular manga for years, yet they're still somewhat under the radar in the U.S. as far as being recognized as a distinct take on Kawaii. Even if you're not familiar with the term *moe*, you are nonetheless likely to recognize this famous style. In fact, it may even already be one of your favorites.

Moe features normal-sized people. They are often loosely based on many of the standard characters that appear in shoujo but with some differences. In addition to being drawn in a romantic style, moe characters are also physically more mature and, therefore, more attractive than their shoujo counterparts.

drawing the moe head

Each view of the head is demonstrated in six progressive steps. I recommend that you start at the beginning. Drawing a well-proportioned head, which is perfectly symmetrical, requires guidelines, like an eye line and a center line; therefore, starting with a basic foundation is essential. Pros don't skimp on this step; however, many beginners often do. And if I find out which one of you is skipping vital steps, why I'll . . . oh, never mind. But for your sake, stick with the instructions. Your drawings will improve as a result.

front view

Draw an extralarge top of the head.

Make the mouth section unusually small, even for manga proportions. And notice how the chin comes to a rounded-off point at the tip.

Here's the top eye line.

Here's the bottom eye line. The eyes are drawn in between the eye lines.

Petite neck

In reality, the head is about five eye-lengths across. But as you can see here, the typical moe-style eye is so large that you can't possibly fit five eyes side by side across the head. Instead, concentrate on placing the eyes at least one eye-length apart, and don't worry about how many eye-lengths wide the head is.

Give hair a nexus, a central point, from which it emanates.

Draw the top eyelids with a thick, dark line. Draw the lower eyelids with a thin, light line.

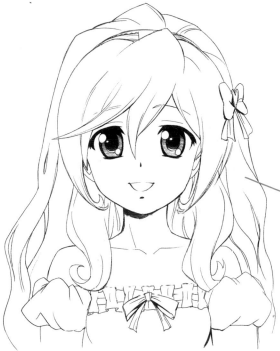

Hair falls in front of the shoulders and behind the back. This gives the illusion of depth by layering in front of, and behind, the girl.

More characters usually have an abundance of hair, making them appear very feminine and pretty.

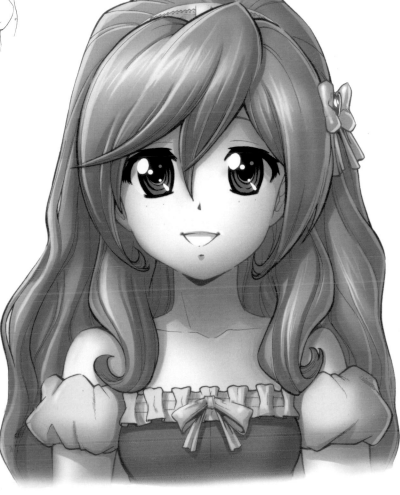

side view (profile)

The side view poses a couple of hurdles for artists, because the front of the face has to be drawn somewhat precisely. But these steps will show you how to overcome those hurdles and create a cool-looking side view.

The good news is that the moe-style profile is highly simplified. The lower half of the profile, from the tip of the nose to the tip of the chin, is almost a smooth line. There are a few speed bumps for the lips, but they're almost insignificant. This makes it one of the easier profiles to draw.

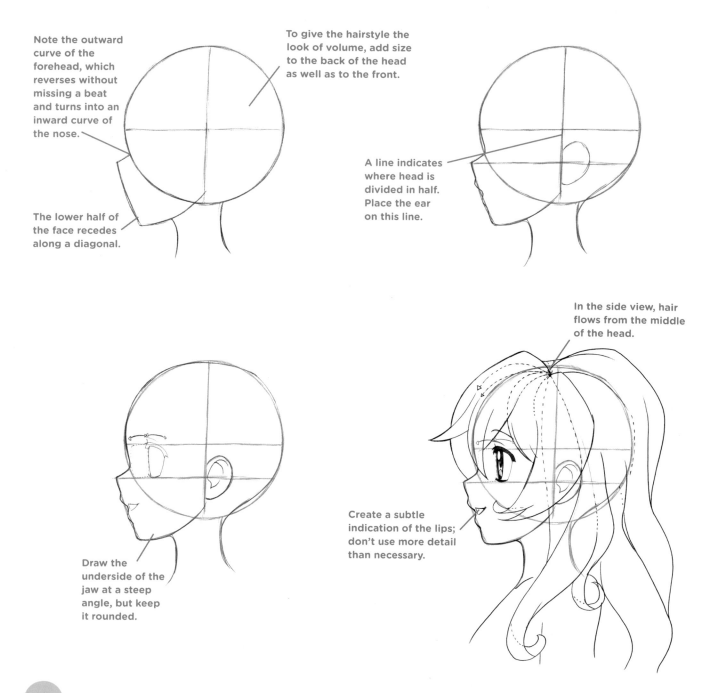

Note the outward curve of the forehead, which reverses without missing a beat and turns into an inward curve of the nose.

The lower half of the face recedes along a diagonal.

To give the hairstyle the look of volume, add size to the back of the head as well as to the front.

A line indicates where head is divided in half. Place the ear on this line.

Draw the underside of the jaw at a steep angle, but keep it rounded.

In the side view, hair flows from the middle of the head.

Create a subtle indication of the lips; don't use more detail than necessary.

Note how upturned the nose is in a side view.

QUICK TIP

It's important that the eyeball is drawn to look slender—not round or fully oval—in profile.

Keep the mouth petite and vary the direction of the waves of the hair.

3/4 view

This is the view you'll probably draw most often for moe characters. Why? The front view and side views are what I call "strict angles." That means that if those angles were to turn, even slightly, they would become something else. For example, if a front view were to shift even slightly from its forward-looking position, it would appear to be a 3/4 view instead. The same holds true for the side view. Therefore, a 3/4 view is a much more forgiving pose. The 3/4 view also emphasizes the roundness of the head and face. In addition, the 3/4 angle causes a subtle but still noticeable effect of perspective on the far eye in the pose. This underscores the illusion of dimension and solidity to the head.

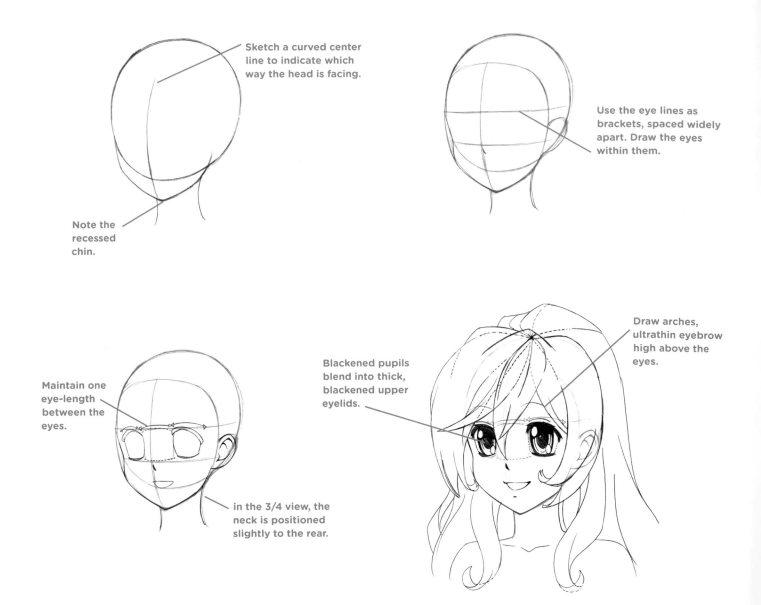

Sketch a curved center line to indicate which way the head is facing.

Note the recessed chin.

Use the eye lines as brackets, spaced widely apart. Draw the eyes within them.

Maintain one eye-length between the eyes.

in the 3/4 view, the neck is positioned slightly to the rear.

Blackened pupils blend into thick, blackened upper eyelids.

Draw arches, ultrathin eyebrow high above the eyes.

Hair falls over the most of the forehead bit also allows us to see some of the eyebrows, without which it would be difficult to ascertain the expression.

Note the subtle shadow under the chin.

Show dynamic hair; it doesn't hang straight down but has body and layers to it.

Note the head is not flat on top, but rounded. This softens the look of the character.

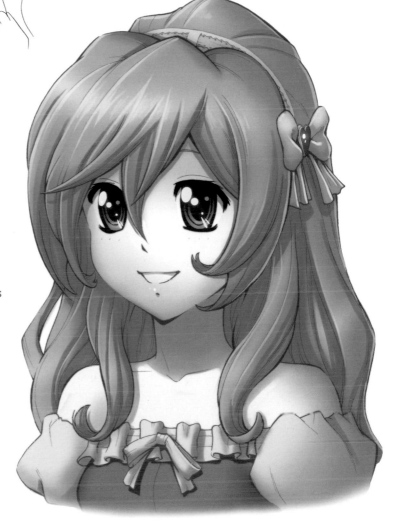

moe hairstyles

Beautiful hair is an intrinsic part of every moe character. Length doesn't matter as much as the style and cut. There are as many hairstyles as there are grains of sand on the beach. Which means there are exactly 16.5 trillion hairstyles to choose from. Man, that's a lot of sand! The strands of hair are drawn with very thin lines, providing an elegant look. But not every strand needs to be drawn. Drawing a group of them will imply the rest. Don't be supercompulsive and attempt to draw ten thousand individual strands of hair on each character's head, or you'll drive yourself crazy.

contemporary hairstyles

Here are a few examples of popular hairstyles worn by modern moe characters.

SHORT BOB
This gives moe characters an especially cute look. Note that the hair curves inward as it frames her face; it doesn't hang straight down.

WINDBLOWN
Showing the effects of wind implies movement and, therefore, adds energy to the scene. It's also an effective way to underscore a feeling of emotional turbulence in a scene.

SUPERLONG PIGTAILS
Length can add glamour to ordinary hairstyles.

SCHOOLGIRL
A headband with the hair brushed back is a squeaky-clean, girl-next-door look. But be sure to make the hair appear somewhat puffy on top of the head to give it volume.

fantasy hairstyles

Streaming, satiny hair is part of the "uniform" of ultrafeminine, cute girls.

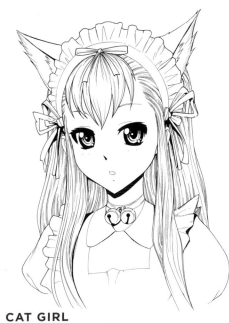

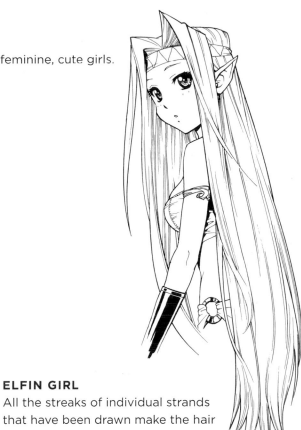

CAT GIRL
Flowing strands of hair fall in front of her ears in gently curving lines.

ELFIN GIRL
All the streaks of individual strands that have been drawn make the hair look silky soft.

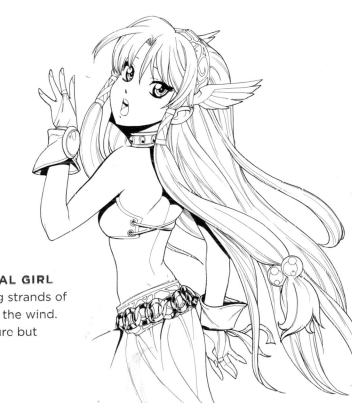

GOTHIC-STYLE MAGICAL GIRL
Multiple groupings of long strands of hair sway up and down in the wind. Character has a good figure but isn't skinny.

drawing the body

The proportions of moe bodies are close to realistic. But realistic proportions are used in other genres of manga, as well. Therefore, we're going to look beyond simple proportions to approximate the style of the moe body. Drawing isn't always about proportions and anatomy. Sometimes, it's also very much about style. Style is an inherent, essential part of manga, cartooning, and comic art overall. This section will point out the important stylistic touches and flourishes commonly seen in moe characters.

front view

The front view is a pleasing angle to draw, because it's so familiar. But it can also bring out your weak spots as an artist. That's because the front pose shows it all: hands, feet, hair, knees, and anything else that you've been trying to conceal from the reader.

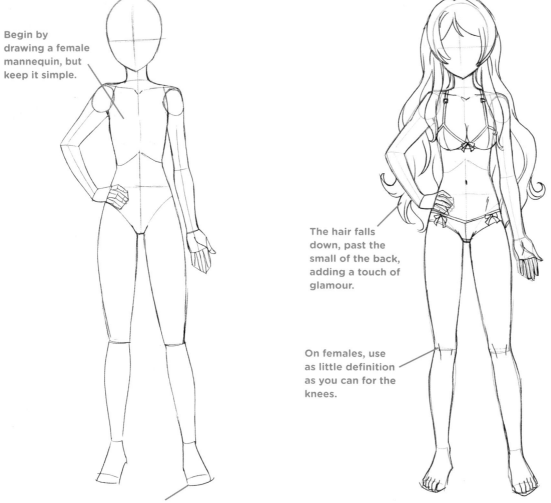

Begin by drawing a female mannequin, but keep it simple.

The hair falls down, past the small of the back, adding a touch of glamour.

On females, use as little definition as you can for the knees.

Point the feet forward, meaning they must be foreshortened, due to perspective. Note how truncated they appear to be.

The billowing sweatshirt covers her upper body. But don't make it too big, or it will make her look unappealing. These characters have long legs.

All the linework is thin and refined, so none of it has to be eliminated and simplified in the final draft.

MOE BODY DETAILS

* Athletic shape to the torso, shoulders, and legs
* Long legs—slightly above the average
* Character has a good figure but isn't skinny
* A curvaceous hourglass-shaped torso
* A soft look to the figure; nothing angular
* A heightened sense of femininity in the details
* Detailed, delicate, and refined linework on both body and clothing

side view

The side view is all about posture. Draw the posture as two poses, combined into one. From the head to the hips, the body is traveling along one line of action; but from the hips down to the feet, the body takes quite a different angle. Let's take a look.

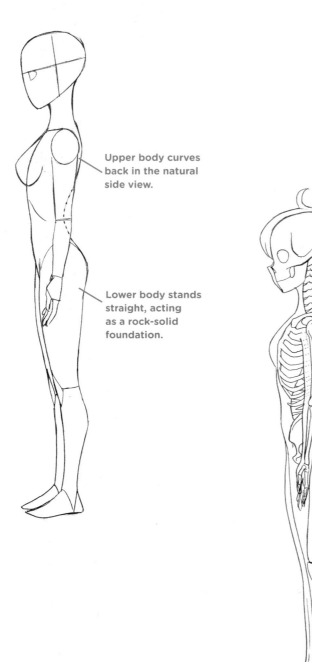

Upper body curves back in the natural side view.

Lower body stands straight, acting as a rock-solid foundation.

Head is held high. Notice the length of the neck. Drawing it too short has an unappealing effect.

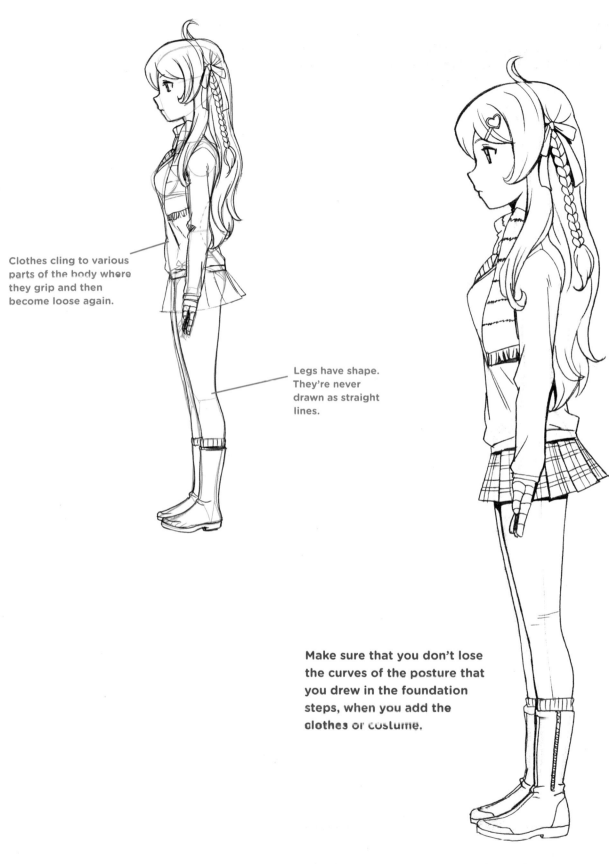

Clothes cling to various parts of the body where they grip and then become loose again.

Legs have shape. They're never drawn as straight lines.

Make sure that you don't lose the curves of the posture that you drew in the foundation steps, when you add the clothes or costume.

3/4 view

Placing one hand on the hip adds variety to an otherwise symmetrical pose.

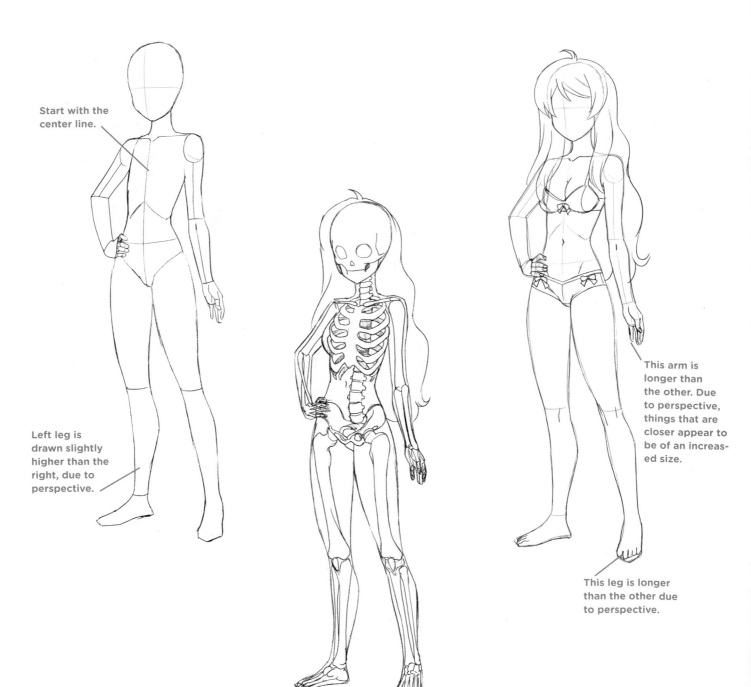

Start with the center line.

Left leg is drawn slightly higher than the right, due to perspective.

This arm is longer than the other. Due to perspective, things that are closer appear to be of an increased size.

This leg is longer than the other due to perspective.

For the 3/4 view, always indicate the center line, not only down the face but down the torso, as well. Everything that appears on the far side of the center line—like shoulders, arms, and legs—should be drawn slightly smaller than the same elements that appear on the near side of the center line.

This foot faces to the side at a side view. The reason the feet face in different directions is because the 3/4 view is split between a front and side view.

This foot faces forward.

The leg that is directly under the torso bears most of the weight; the leg that is away (the right one here) is relaxed.

essential moe characters

Having mowed down the basics like a banshee attacking a chicken sandwich, like a half-starved intern at a company picnic, you're now ready to draw the pretty females that have made moe one of the most popular genres in Japan. (How's that for torturing a metaphor?) The following section serves up a wide variety of moe characters and their corresponding tutorials. In each case, note the emphasis that has been placed on three main features: a pair of large, luminous eyes; a delicate expression; and ultrafeminine body, costume, and hair.

cat-girl french maid

Look at that sweet expression and those big ears. Awww . . . so kawaii!

Seemingly incongruous combinations, such as this cat girl in a French maid's outfit, are far from uncommon in the moe genre. In fact, this style is strong enough to allow for all sorts of creative combos. Rather than appearing odd or weird, disparate combos like this look cool, even attractive. The trick is to use the catlike features as a device to accentuate the overall feeling of femininity, rather than to impose an animal quality. Even with cat ears, she's like any other girl. It's just that she happens to prefer a ball of twine over clothes and shoes.

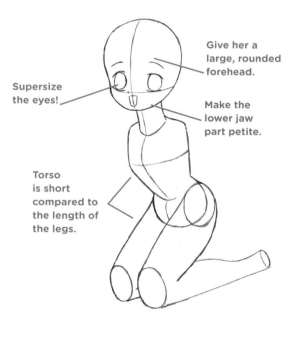

Give her a large, rounded forehead.

Supersize the eyes!

Make the lower jaw part petite.

Torso is short compared to the length of the legs.

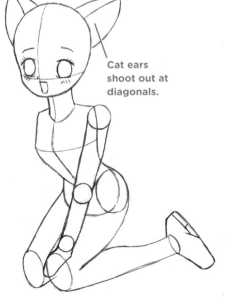

Cat ears shoot out at diagonals.

Hair brushes
outward.

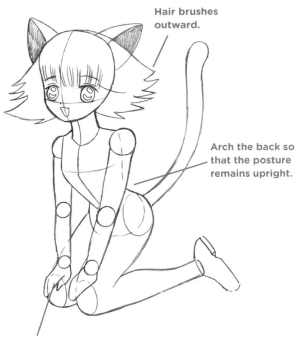

Arch the back so
that the posture
remains upright.

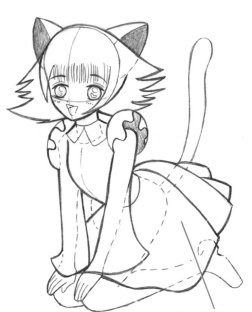

Place the hands and knees
close together.

Give the fabric some extra
volume so that it doesn't
collapse on her.

Note the use of wispy colors, rather than
a palette of primary colors. Primary colors
convey a bold energy, which derives partly
from their striking contrast. By applying
several variations of a single, muted color,
like this periwinkle blue, you convey a
gentler tone, which makes a moe character
more sympathetic.

waitress

Waitresses, and other beautiful, glamorized service workers, are superpopular in manga, especially among the Japanese teenage girls who make up a large demographic of its readers. These characters can be anything from chefs to stewardesses to hairdressers and hostesses.

Why are service workers so often portrayed in the moe style? Because service workers are supposed to be helpful and caring (unless they're providing tech support for my printer!). Moe characters are famous for their helpful and caring emotions. It's a natural fit.

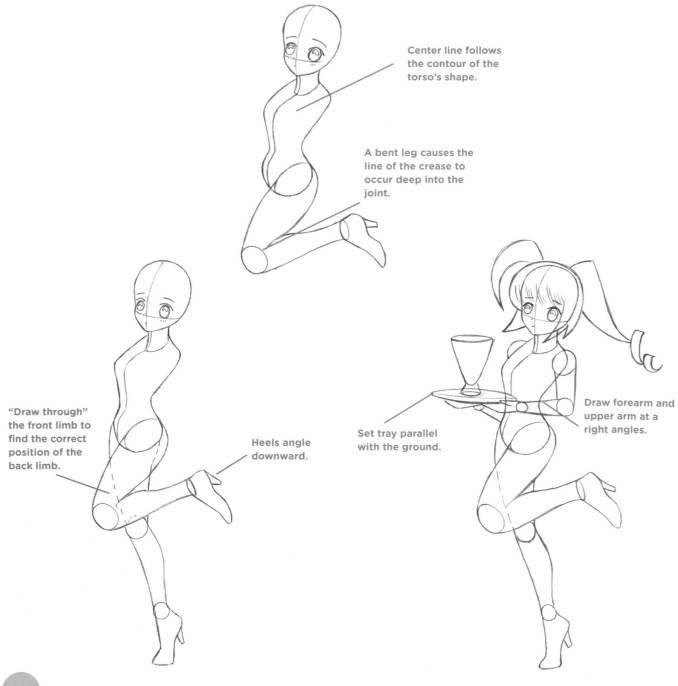

Center line follows the contour of the torso's shape.

A bent leg causes the line of the crease to occur deep into the joint.

"Draw through" the front limb to find the correct position of the back limb.

Heels angle downward.

Set tray parallel with the ground.

Draw forearm and upper arm at a right angles.

Draw the costume over the figure, before erasing the underlying structure. Note how the skirt fans out like an umbrella.

QUICK TIP

Important: Don't forget to show the far shoulder peeking out from behind the torso; this gives the figure a three-dimensional appearance. Don't eliminate parts of the body just to make a character simpler to draw.

The outfit is frilly, pretty, and traditional. So what's with the outrageous hair color? Did she simply not want to hurt the feelings of her color-blind hair colorist? Or did her younger brother "crayon" it while she was sleeping? No, my suspicious friend, no. Although moe characters aren't generally outrageously colored, you can go a bit off the trail by keeping your color selection muted, such as this sea-green.

cute beauty

In Japan, many popular moe characters are designed with sex appeal first and cute appeal second. They're never drawn with the anorexic look of a magazine fashion model. On the other extreme, many popular moe characters, which haven't been edited and translated for Western audiences, often feature characters with proportions that are downright ridiculous. Stay somewhere in middle, and be tasteful in your approach.

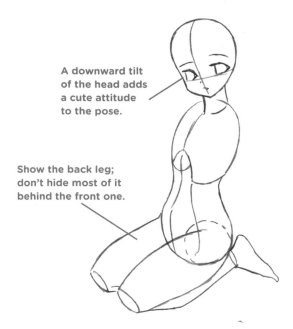

A downward tilt of the head adds a cute attitude to the pose.

Show the back leg; don't hide most of it behind the front one.

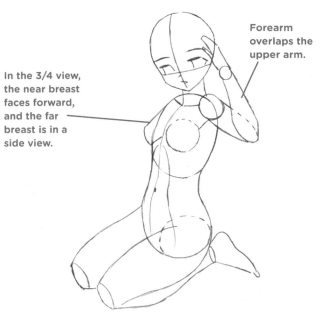

In the 3/4 view, the near breast faces forward, and the far breast is in a side view.

Forearm overlaps the upper arm.

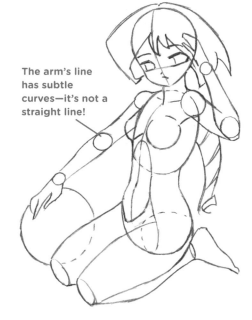

The arm's line has subtle curves—it's not a straight line!

Note the deceptively large hat: The back of the brim makes contact with the shoulders and the back of the neck.

Adding relevant props can add fun and help to clarify the location of a scene.

This scene looks like a warm day. How did that happen? Not by chance. It's due to the way the light was portrayed. To represent stark sunlight, show harsh shadows by indicating one light side and one darker side. The hotter you want it to look, the greater the contrast should be between the two tones (in other words, the lighter one side, the darker the other). Don't show any gradation whatsoever between the two tones—no transition. It's an abrupt line between light and dark.

holiday girl

These ever-cheerful holiday characters are popular staples and almost exclusively found in the Kawaii genre. They're playful teens who dress up in a variety of fun costumes, from Santa's helper to flirty Halloween devils. They are most often portrayed as having fun—with an exuberance that is contagious. In addition to appearing in graphic novels, they also serve as superb visuals for advertising pieces, promotions, logos, and greeting cards.

Note that the basic construction of the torso is created from three simple shapes.

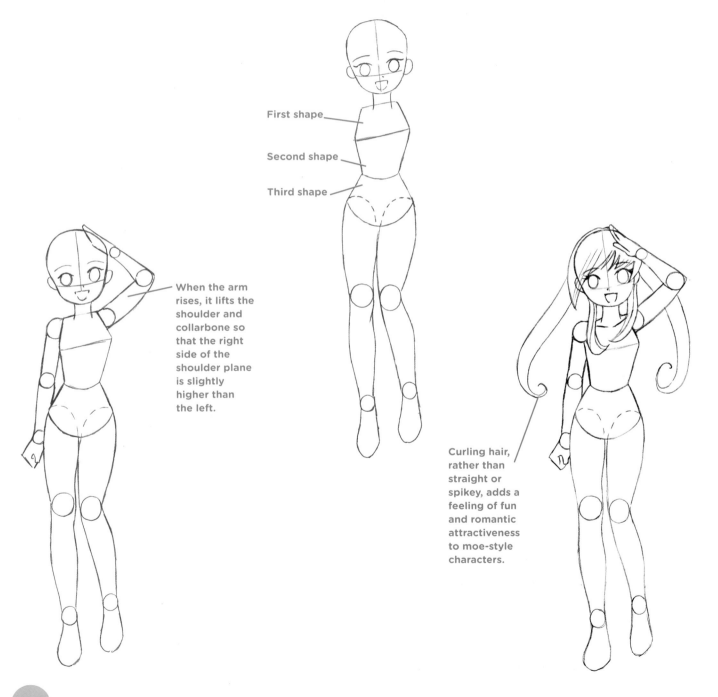

First shape

Second shape

Third shape

When the arm rises, it lifts the shoulder and collarbone so that the right side of the shoulder plane is slightly higher than the left.

Curling hair, rather than straight or spikey, adds a feeling of fun and romantic attractiveness to moe-style characters.

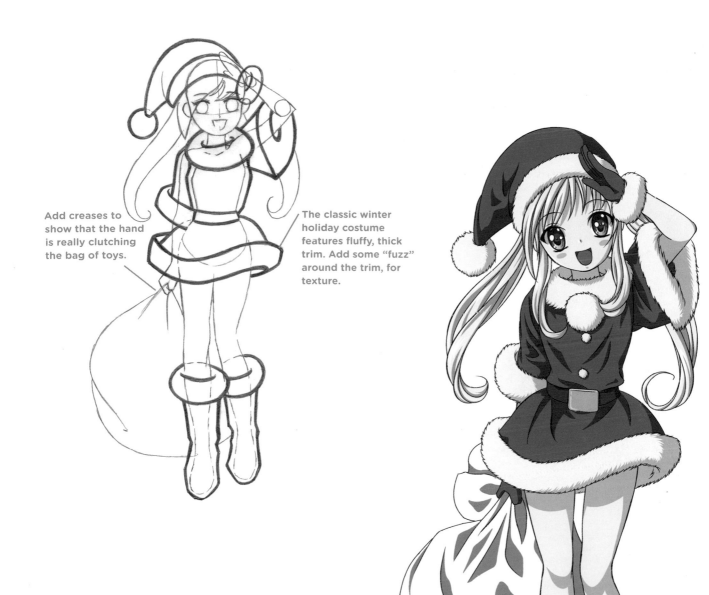

Add creases to show that the hand is really clutching the bag of toys.

The classic winter holiday costume features fluffy, thick trim. Add some "fuzz" around the trim, for texture.

Sometimes, an outfit's theme is so strong you almost have to give it preordained colors. Such is the case with the ever-popular red-and-white holiday-cheer outfits. Even then, however, there is still some room to maneuver. A green outfit with white trim suggests a slightly elfish theme but still communicates the spirit of joy and winter. Just don't make it plaid.

graceful angel

Does this type of character look somewhat familiar to you? Take a moment. If it does, that's because robed, winged, ethereal angels appear in many styles of manga and across many genres, from moe to shoujo and shounen and even in the darker styles, like occult and horror. And yet, the attractive angel is most often drawn in the moe style, even when appearing in other genres. That's because the grace and beauty of the archetypical angel character is best suited to the approach found in moe.

Avoid the common beginner's mistake in this type of pose: knees at different heights. Both knees should be at the same level, as they are here; if you draw one higher, then one leg will appear to be shorter than the other.

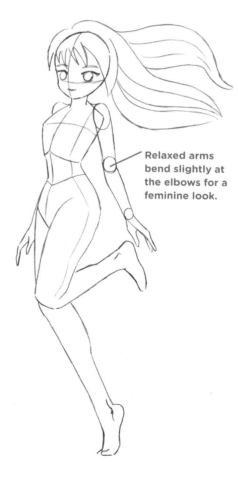

Relaxed arms bend slightly at the elbows for a feminine look.

QUICK TIP

Although the attire mostly obscures the body, constructing the body first results in a more convincing final figure.

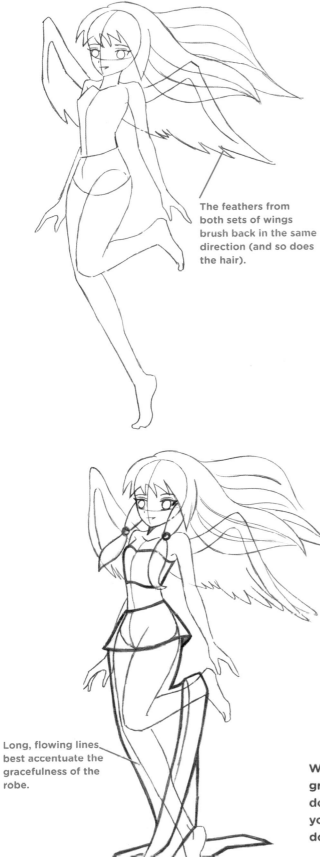

The feathers from both sets of wings brush back in the same direction (and so does the hair).

Long, flowing lines best accentuate the gracefulness of the robe.

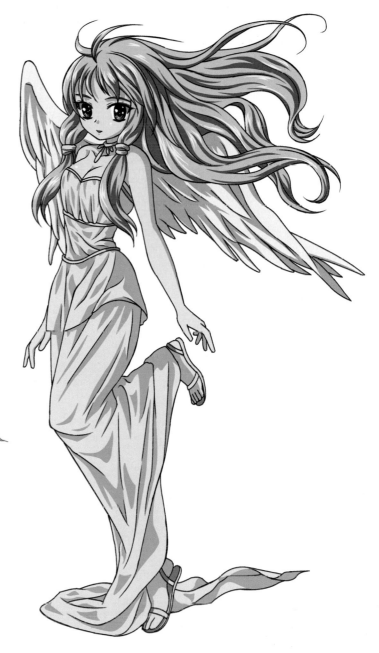

Wings are generally tinged with highlights of blue, gray, or lavender; however, this is fantasy—you can do what you want. What's someone going to say if you color them pink or light green? "Hey, those wings don't look real"? None of it's real!

traditional japanese girl

Traditional Japanese outfits immediately signal to the reader that the story takes place in Japan. Characters who wear kimonos are often portrayed as modest and polite, which makes sense, because their clothing reflects their traditional values. The modest grace of moe makes an excellent choice for this character type.

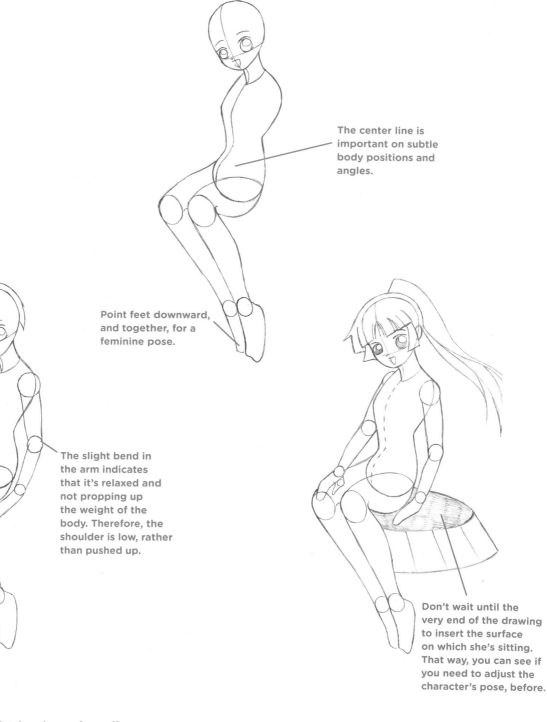

The center line is important on subtle body positions and angles.

Point feet downward, and together, for a feminine pose.

The slight bend in the arm indicates that it's relaxed and not propping up the weight of the body. Therefore, the shoulder is low, rather than pushed up.

Don't wait until the very end of the drawing to insert the surface on which she's sitting. That way, you can see if you need to adjust the character's pose, before.

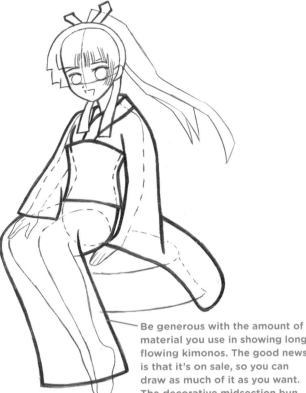

Be generous with the amount of material you use in showing long, flowing kimonos. The good news is that it's on sale, so you can draw as much of it as you want. The decorative midsection bun and tie are very traditional.

The pleasing outfit is both light and airy. But however attractive it may be, it also lacks visual impact. For the character to pop out at you, something has to be done to counterbalance this wispiness. Therefore, the hair has been colored as darkly as the kimono has been colored lightly. Alternatively, blond hair would have been a disaster, washing out the image entirely.

putting it all together

This chapter presents great projects for creating charming worlds and scenes for your supercute characters. Each one of these projects requires your creativity and the skills you've learned so far. But you can do it! Included are important tips on composition and backgrounds. In addition, there's an irresistible section on creating cute and funny greeting cards in the Kawaii style.

And finally, this chapter explores how you can take your passion for Kawaii and turn it into a career—real advice for the aspiring manga artist.

177

drawing supercute scenes

The following scenes are fun projects. No one would expect you to complete one in a single sitting. Do them at a relaxed pace and have fun. Take several days, a week, or several weeks. I suggest drawing the backgrounds before drawing the characters. You'll probably find it easier to draw characters in existing backgrounds, rather than to draw the setting around randomly placed characters.

sugar town

The Sugar Town scene will give you the opportunity to combine little characters with personality with personality-driven candies and treats. This delightful world of sweetness is so cute it may send you into sugar shock. But you can handle it.

ROUGH STAGE

In a panoramic scene like this, the width of the landscape allows there to be many different areas of interest, not just one focal point to the scene.

Initially, keep it simple and strive only for placement. This allows you to redraw quickly and easily, to try out new ideas and attempt to achieve the best layout. If, instead, you tried to draw everything perfectly right from the start, you'd have a hard time mustering the will to redraw if a better approach occurred to you. Admit it. You know what I'm saying is true. Don't force me to use a polygraph on you. I will if I have to.

BLACK-AND-WHITE INK STAGE

Don't worry about how messy your drawings get—that's what they make light boxes for. You can buy one in many art stores or online. They're not expensive. You want a simple one. They shine a light through a box that you draw on. You simply trace over the messy drawing onto a clean piece of drawing paper to create a clean, finished version without having to erase a thing. Simple! That's how the pros do it.

MAJOR POINTS OF INTEREST
* Gumball machine and friends
* Ice cream towers
* Ice cream layer-cake house
* Rainbow and lollipop plaza
* Rooftop snowdrift. Be careful not to fall! You might end up on that gooey ice cream sundae directly below!

COLOR STAGE

There are many different ways to color a drawing. Some people like to use markers. Others use colored pencils, which now come in an amazing variety of styles. Watercolor is tricky, tricky, tricky—especially when applying it to small, detailed drawings. Oil-based pastels are so awful for precision work they'll make you wish you were in English class listening to a lecture about the classics, maybe even sonnets. Well, maybe it's not quite that bad, but then, what is?

When you enter an old-fashioned ice cream parlor or candy store, the thing that strikes you first is how colorful it is inside. The wide variety of colors reflects the wide variety of confectionery items and scoops of different-flavored ice cream. As artists, we can probably imagine that a hodgepodge of different colors, put together in the same scene, won't look terribly appealing. And yet, this scene is delightful. There must be a unifying theme. Can you tell what it is? It's subtle, but it's there, all over the picture.

It's the strength of the colors—it's uniform. Most of the background colors have a pastel cast to them. They're light and airy, while the people are colored in bold, primary, and deep colors. This gives the scene a cheerful but soft fantasy feeling.

all aboard!

Here's an important hint that can help you bring out the most in this scene and increase its appeal to readers: Squeeze as much into the picture as possible—characters, props, and things. It'll be a treat for reader's eye. But it only works if you keep the drawings simplified and allow each image room to breathe. Don't cramp things. Try not to overlap too many elements by drawing one person standing in front of another, for example.

ROUGH STAGE

The toylike train leads the viewer's eye all the way from the left side of the page to the right side on a dynamic diagonal. It also shows accelerated perspective, which grabs the reader's attention. But this attention-grabbing technique could easily overpower the picture. Therefore, it's important to balance it out with appealing images in front of and behind the train (i.e., in the foreground and background). In the foreground, cute conductors and passengers are taking tickets and saying their good-byes. In the background, the quaint town is bustling with activity.

QUICK TIP

The smaller the details that you are drawing, the thinner your pencil or ink line should be. A thick line makes tiny details look cartoonish and clumsy. A finer line keeps them clear.

Things that suggest architectural charm are Tudor beams, chimneys, turrets, multiple windowpanes, and steeply pitched roofs.

Inanimate objects also contribute significantly to crushingly sweet scenes such as this one. The smoke from the train has been drawn with a ton of precious curls and swirls, using a decorative line found in storybooks.

Here's another face in the sky—this time on the sun.

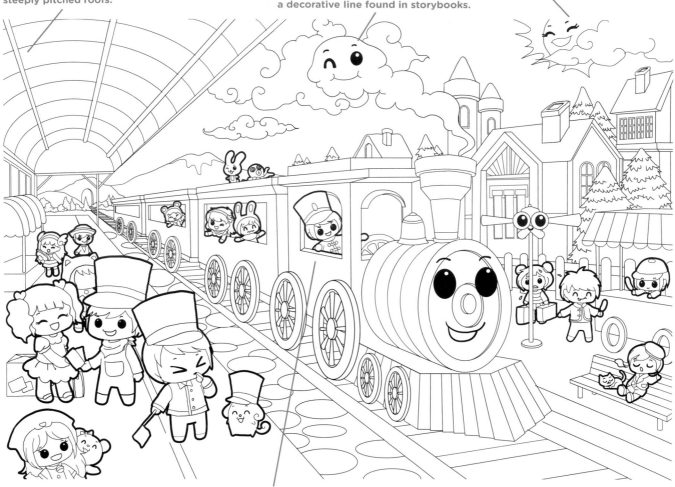

Characters lean their heads out the window. It's easier for the viewer to see them that way and creates a better, more natural-looking pose. In Kawaii, even the conductors are drawn so that they appear young.

MAJOR AREAS OF INTEREST

* Train is drawn on a diagonal, with the train cars increasing in size as they appear to approach us.
* Figures in the foreground
* Figures and houses in the background
* The roofline is also drawn on a diagonal and recedes toward the horizon line.
* Horizon line

COLOR STAGE

This charming scene looks happy and bouncy with the help of a wide array of colors in the red-orange-yellow spectrum.

The variety of different colors in this picture makes it look like fun, and yet, the colors have also been used to tie everything together. The individual train cars are all different colors, but the ten wheels on our side of the train are the same: yellow. That's an example of using color as the unifying element of a composition.

In addition, large color areas tie the foreground to the background. On the left side of the scene, the roof of the train station is beige, as are most of the quaint houses across the street.

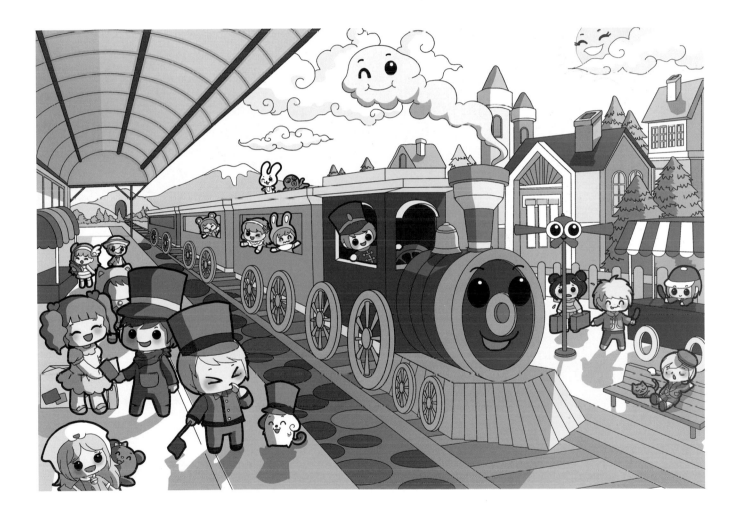

supercute greeting cards

Supercute characters make great subjects for greeting cards and e-cards. You can send them to friends and family. This is another opportunity to expand your skills in creating humorous scenes rather than just single-person character designs.

At this point, you're probably wondering, "How do I come up with funny ideas?" Good question! There are two basic ways to spark your imagination that will generate ideas for jokes and funny scenes, and both will be explored in the next few pages. The first is to treat the occasion—whether it's a holiday, birthday, or any other special time—as the "setup" for a visual punch line. Play off the reader's expectations. Use sarcasm and irony, and go "against type" (take classic scenes that represent the occasion, and mangle them with a witty but strange depiction of events).

A second way is to draw the greeting card exactly as the reader would expect it but to introduce a surprise element into the scene, which can be cute, funny, weird, or darkly funny. Either way, make a little mischief with it!

valentine's day

Who doesn't like getting a card that expresses love and affection? Have fun with this. Create a card to send back to your true love that shows your innermost feelings.

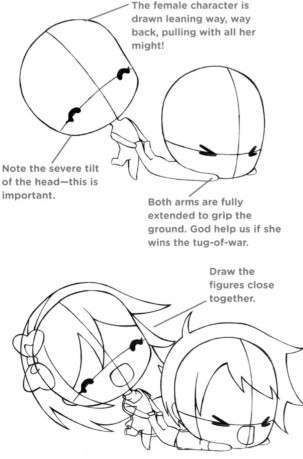

The female character is drawn leaning way, way back, pulling with all her might!

Note the severe tilt of the head—this is important.

Both arms are fully extended to grip the ground. God help us if she wins the tug-of-war.

Draw the figures close together.

The humor comes from the contrast of expressions: Both characters have their mouths open wide—hers in a smile; his in a desperate cry!

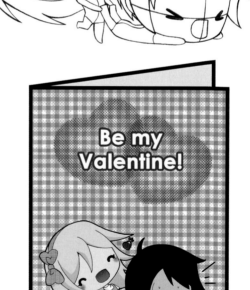

Be my Valentine!

You can add a sound effect to enhance the humor. Those lines to the right of the boy's face are visual sound effects that indicate he's calling for help—but no one's coming to his rescue.

get well soon!

Here's a good example of a scene with a surprise element. The sick kid has a thermometer in his mouth, as one would expect. The surprise element is that his puppy also has a thermometer in its mouth. The exaggerated dimensions (the boy is practically larger than the bed!) also add to the humor of the scene.

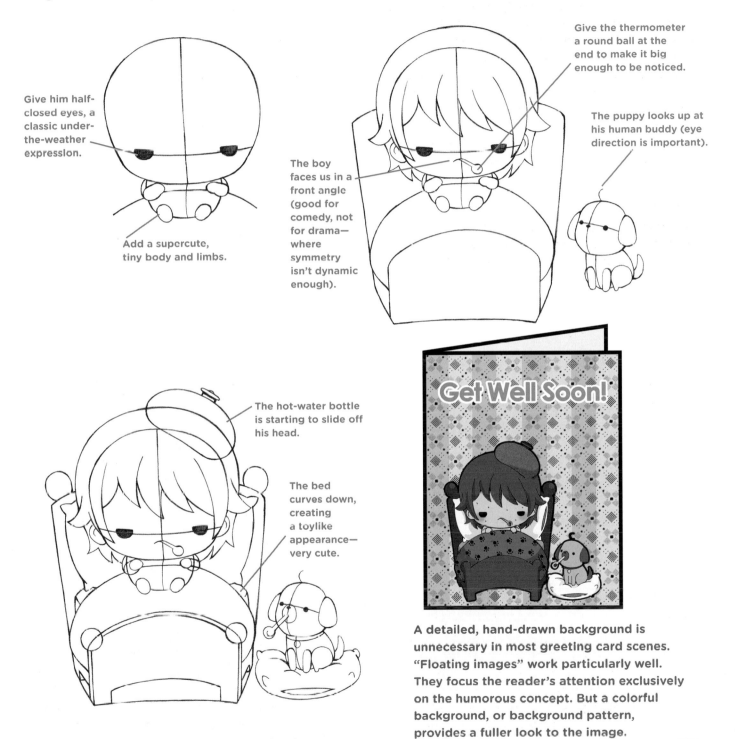

Give him half-closed eyes, a classic under-the-weather expression.

Add a supercute, tiny body and limbs.

Give the thermometer a round ball at the end to make it big enough to be noticed.

The puppy looks up at his human buddy (eye direction is important).

The boy faces us in a front angle (good for comedy, not for drama—where symmetry isn't dynamic enough).

The hot-water bottle is starting to slide off his head.

The bed curves down, creating a toylike appearance— very cute.

A detailed, hand-drawn background is unnecessary in most greeting card scenes. "Floating images" work particularly well. They focus the reader's attention exclusively on the humorous concept. But a colorful background, or background pattern, provides a fuller look to the image.

holiday greetings

The humor in this greeting card comes from injecting a playful element into an otherwise idyllic winter scene: A big, fat snowball is headed right for the boy's noggin. This implied action is actually funnier than the action itself.

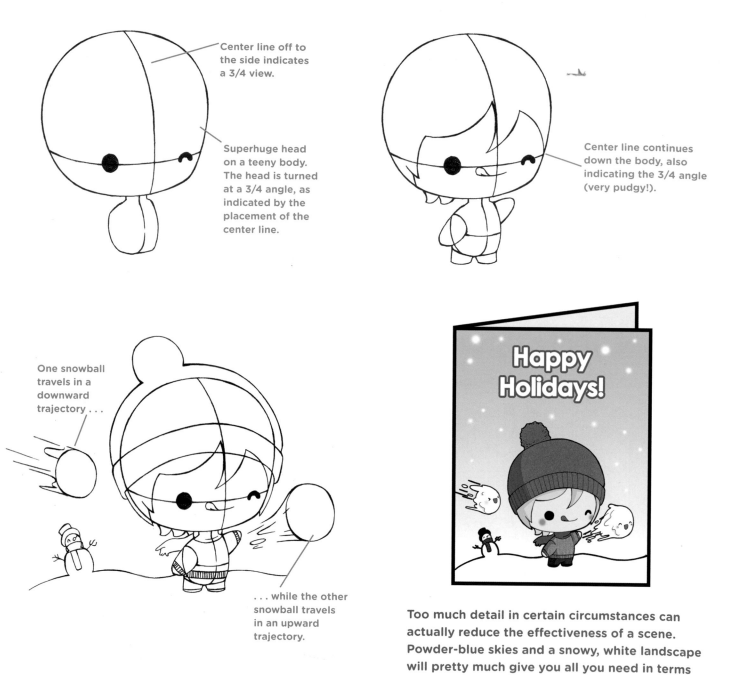

Center line off to the side indicates a 3/4 view.

Superhuge head on a teeny body. The head is turned at a 3/4 angle, as indicated by the placement of the center line.

Center line continues down the body, also indicating the 3/4 angle (very pudgy!).

One snowball travels in a downward trajectory . . .

. . . while the other snowball travels in an upward trajectory.

Happy Holidays!

Too much detail in certain circumstances can actually reduce the effectiveness of a scene. Powder-blue skies and a snowy, white landscape will pretty much give you all you need in terms of a winter backdrop.

a moving card with a twist

Similar in style to the Valentine's Day card, this humorous relocation announcement adds a clever twist to the well-trodden, happy scenario of moving on to greener pastures. This little Kawaii guy is being forced to leave, kicking and screaming! He has been tied to the house, which itself is being moved—a funny, unexpected visual.

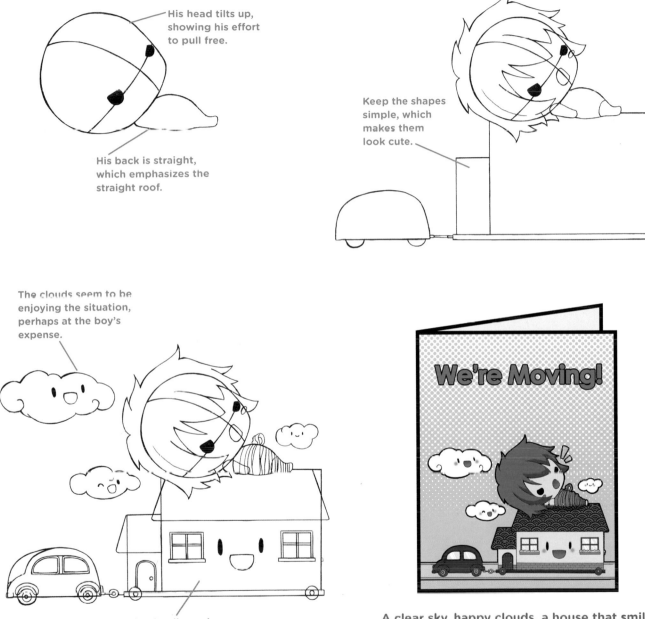

His head tilts up, showing his effort to pull free.

His back is straight, which emphasizes the straight roof.

Keep the shapes simple, which makes them look cute.

The clouds seem to be enjoying the situation, perhaps at the boy's expense.

Make the dimensions funny: He's a tiny character—but gigantic when compared to the size of his own house! How did he even fit in there.

We're Moving!

A clear sky, happy clouds, a house that smiles, and not a drop of rain. What a wonderful day it is! All that cheerfulness must be torture for that poor kid!

turning your kawaii passion into a business

Do you love to draw the cute characters of Kawaii that make it such an irresistible style? Do you keep a sketchbook of your work? Is your floor is covered with drawings? Perhaps you show your creations to friends, who "ooh" and "aah" over them. Some of you might even be brave enough to post some of your stuff online in manga groups for critiques. That's a great start. But have you ever thought of offering your work for sale and actually making money from your art?

Products, like mugs, benefit from the use of Kawaii graphics. They transform the mug into an instant attention-grabber.

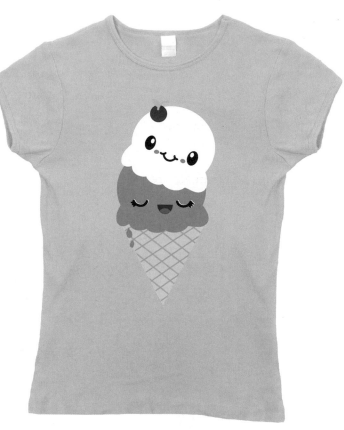

Apparel, such as T-shirts and hats, also use licensed characters to help move the merchandise.

meet two working kawaii artists

Carol Regli and Courtney Regli (a mother-and-daughter team) of Bored, Inc., began like many of you, drawing Kawaii for the love of it. Being resourceful and determined, they chased their dream and refused to give up. Today they own an established art studio that licenses its original Kawaii art on merchandise in apparel stores, galleries, and toy shops all over the world, including Hot Topic, ToysRUs.com, and FAOSchwartz.com. The examples on page 188 come from their studio. This section features an exclusive interview with the artists, who tell you exactly how they did it and how you can, too.

- -

HART: When did you start getting interested in the Kawaii style?

BORED, INC.: We'd always been interested in cute art and characters, but we didn't come to fully appreciate Kawaii until we traveled to Japan. In Japan, cute character art is a part of everyday life, and we were so excited when we became immersed in cute imagery—it was on everything from menus to vegetable packaging. We realized that seeing cute, happy imagery on everything left us really appreciating the Kawaii style, and it was something we wanted to integrate into our own art from then on.

HART: A lot of aspiring artists dream of selling their work but don't have the confidence to market it. What gave you the courage to take that first step?

BORED, INC.: When we decided we wanted our art to be in the Kawaii style, it was a big departure from the type of art we had been making. We started off with just a few pieces and presented them on a few products. Once we saw how much people liked them, it really gave us the confidence to create more Kawaii imagery. When you create something and someone sees it and loves it, it's incredibly rewarding and makes you want to create more designs. We are so appreciative of the fans who come to our shows, purchase our products, and support us. It's because of their support and encouragement that we get to do what we love.

HART: What advice would you give newcomers to the field?

BORED, INC.: Create artwork and characters that you can really be proud of. It's fine to be influenced by other artists, but it's most important that you work on creating a brand that is 100 percent your own. Once you've created artwork that you are proud of, put it out there! A lot of people say they are scared to show their work because it might get ripped off or people might not like it. But you'll never know what the response is unless other people get to see it. Be brave and stand behind your work, and pretty soon you'll start to get fans who appreciate what you do and encourage you to create more!

three secrets to becoming a successful kawaii artist

Kawaii artists often discover the following important principles to a successful career only after years of trial and error—and sometimes not even then. But you can take a shortcut around the common mistakes by following these three simple suggestions.

CREATE AN EFFECTIVE PORTFOLIO

You'll need a portfolio of your work for prospective clients to view. When selecting pieces to show, first make an honest appraisal of your work, and decide what you draw best. Only display the cream of the crop—even if there isn't much variety in your selections. Here's why: All licensed pros specialize. Specializing allows you to showcase your best stuff, whereas offering weaker examples of every style, in an effort to compete for every assignment out there, only lowers the perceived quality of your entire portfolio. But the most important benefit of specializing is that it "brands" an artist. As a result, when clients or companies need to obtain that specific style, they will think of that artist first.

Super Cute Illustrations
FOR SALE!

BUILD A STELLAR REPUTATION AS A PRO

Deliver on time. There is no exception to this rule. To make this happen, communicate regularly with your clients, showing them the roughs of the work in progress. This lets clients know you're staying on schedule and allows them to offer feedback.

Show a willingness to make the changes requested by the client; however, there are some clients who don't know exactly what they want and continue to request change after change out of indecisiveness. It should be agreed at the outset that if more than two sets of changes are requested, each subsequent set will add an additional charge to the project.

CREATE AN IMAGE OF EFFECTIVENESS

Look expensive. That's right. Your website should look professional and not homespun. People feel more confident in purchasing professional-looking products from a professional-looking website.

index